BLACK AMERICA SERIES

EAST POINT
GEORGIA

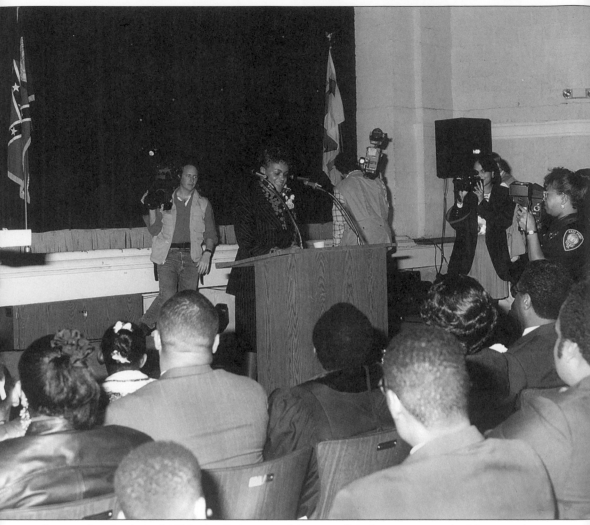

During the election of 1992, East Point moved into a political arena unmatched by many larger cities, including Atlanta. Patsy Jo Hilliard was elected its first African-American female mayor. Hilliard is shown in the photo above at her inauguration, following her swearing-in by Justice Lear Sears. The mayor's respect and passion for the city's early and undocumented history of the African-American community led her to organize a committee for the purpose of preserving this legacy. This publication is a fulfillment of her vision to have a book documenting the rich history of African Americans in East Point, Georgia.

BLACK AMERICA SERIES

EAST POINT
GEORGIA

Herman "Skip" Mason Jr.

ARCADIA

Published by Arcadia Publishing,
an imprint of Tempus Publishing, Inc.
2 Cumberland Street
Charleston, SC 29401

Printed in Great Britain.

Library of Congress Catalog Card Number: 2001092145

For all general information contact Arcadia Publishing at:
Telephone 843-853-2070
Fax 843-853-0044
E-Mail sales@arcadiapublishing.com

For customer service and orders:
Toll-Free 1-888-313-2665

Visit us on the internet at http://www.arcadiapublishing.com

CONTENTS

FOREWORD

This book is the history of the African-American community in the city of East Point, Georgia from the 1800s through 1980. To capture the history of this community in prose and pictures is truly a remarkable and outstanding event.

How did this project begin? First, let me begin by acknowledging my favorite academic subjects. Those subjects are science and history because both require the collection and recording of data. In addition, both subjects attempt to answer the questions of "when," "where," and "how." As a result of my interest in these subjects, I have saved old family pictures and documents, and collected articles relating to an historical event that occurred in the city. Secondly, I shared these articles several years ago with the Honorable Patsy Jo Hilliard, mayor of the city of East Point. She suggested that a book be published about the rich heritage of this community.

Through the collaborative efforts of the mayor, our sponsors, the citizens, churches, and community organizations, this project has become a reality. I wish to thank the mayor for her vision on the significance of the project. She contacted the author, the Rev. Herman "Skip" Mason Jr., and the sponsors of the project to begin work on chronicling the history of African Americans in East Point.

To the sponsors, Booker Izell and the *Atlanta Journal Constitution*, Citizens Trust Bank, Coca-Cola, CH2MHill, Fannie Mae, and one who wishes to remain anonymous, I thank you for believing that this project was important enough for your financial support. Without your support, the project would not have been possible. To all of the citizens who brought materials that were used in the book and gave oral interviews, I thank you for your demonstration of community pride. Thanks to the churches in the Fifth Sunday Union for your monetary contribution. Thanks to the Alpha Center for providing a place to host the homecoming program and to all of the participants on the program for donating your services and time. I also express my sincere thanks to the East Point Historical Society for hosting the kick-off program for the project. I would like to extend a very special thanks to the African-American History Committee, Mr. James E. Stokes, co-chair, for planning, implementing, and coordinating this project. To Herman "Skip" Mason, I enjoyed working with you and thank you for bringing this community's rich past into the present for all to enjoy.

I hope this book will be an inspiration to the African-American citizens, especially the youth of this city, and will serve as a vehicle to instill a positive commitment to the future growth and development of our community. Finally, I encourage all citizens to individually collect family memorabilia so that your family's history will remain viable for future generations.

—Maggie Patricianne Hurd, Ph.D.
Chairman, African-American History Committee

INTRODUCTION

I am blessed to be able to share this history of African-American life in East Point, Georgia. Several years ago, I met Mayor Patsy Hilliard at a Link's Anniversary celebration and shared with her the history that I had compiled on Alpha Phi Alpha Fraternity. Two years ago, she contacted me and indicated her desire to have a history documented and published of the city.

As a native of Atlanta, I will admit that my lack of knowledge about the old black community of East Point was limited. As a child growing up in the Ben Hill and the Greenbriar areas, East Point meant Headland High School, and the old Smorgasbord Buffet, which stood at the fork of Cleveland and Norman Berry Streets. I had never visited downtown East Point. For me this would be a great challenge to learn about a community literally right at my doorsteps.

With initial support from Booker Izell and the *Atlanta Journal Constitution* and the formation of the East Point African-American Historical Committee, the project moved forward. At my first meeting with the committee, Sam Roberts, or "Mr. Sam" as he is called, shared so much information that I regret that I was not prepared to record it. I arranged a street-by-street tour with James Jackson and Sam Roberts, two living historians filled with knowledge about their home community. They remembered where old businesses once stood and where families once lived; they had wonderful anecdotes that were priceless—some were printable and some were for my ears only.

I received a copy of a document prepared by Anne S. Larcrom which chronicled many of the African-American churches in East Point and other aspects of the city's history. This document and her research were invaluable. Much of her research is included in this book, with her blessings and permission. While there were still many areas yet documented, Larcrom's research gave me a wonderful base to quickly learn about the area and some of the people that I would be researching.

The celebration of the East Point Reunion in February of 2001 brought former and current residents to the Alpha Community Center, formerly the East Point Elementary School and later renamed Quillian Elementary School. Men and women brought with them photo albums, scrapbooks, and newspaper clippings, adding to the collective history of this city. With my camcorder, I spent over six hours interviewing and videotaping many of these citizens, both African-American and white, as they recounted their memories of growing up in the city and what made it special for them.

Traveling south on Childress, and east on Headland Drive, one views spacious and sprawling brick homes, including such cross streets as Forest Drive, Dodson Drive, Bryant Drive, and Plantation Drive. African Americans have moved into streets formerly occupied by whites, including Duke of Gloucester, and into such communities as Sumner Park and Jefferson Park. However, the history of East Point will show that this has not always been the case. Most African Americans were confined to a small, boxed-in area known as the Fourth Ward.

I learned that though the geographical area of the early African-American community was

small, there was a strong sense of family ties and community. This was a place where "everybody knew everybody." Downtown East Point—once vibrant with stores such as Woolworth and Sears—is now a quiet and subdued small town with dreams of economic revitalization. The construction of Marta (Atlanta's Rapid Rail system) and the past use of the train depot (for which the city had its origin) have contributed to its revitalization. The construction of the Hilliards, a mixed-use facility on Main Street developed by Andrea Wynn, indicates efforts to attract new residents to the city.

While African Americans live all over East Point, including Jefferson Park and other areas that were all white, today East Point is characterized by sprawling homes in the Colonial Hills and Ward D area owned by African Americans. The opportunity for African Americans to acquire these homes came as a result of a "white flight" in which longtime white residents moved to DeKalb, Fayette, and Henry Counties in droves in the late 1960s and 1970s and African-Americans encroached on what they considered their territories. In addition, the Urban Renewal project in the Fourth Ward provided opportunities for African Americans to replace dilapidated houses with new brick homes. White residents sold their houses and left their churches. Many of the large churches in the community, such as Rev. Dale Bronner's Word of Faith Church, were once all-white congregations.

As African Americans began to move to the sprawling areas of East Point and creating a secure middle-class community, black-owned businesses developed. Griff Askew, who grew up in East Point and attended South Fulton High School, opened a formal wear shop for men. The business is located on Church Street. In 1995, Jim and Genise Brown opened Heaven Sent Gospel Supper Club on Ware Avenue. The increase of economic vitality is vibrant in East Point today.

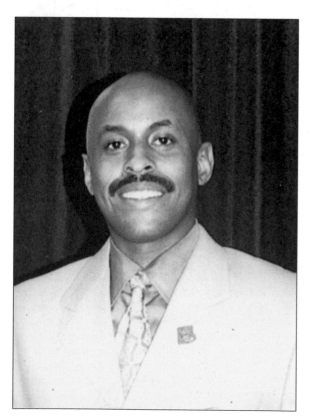

ABOUT THE AUTHOR

Author Rev. Herman "Skip" Mason Jr. has published numerous books on the African-American experience including *Going Against The Wind*, *The Talented Tenth*, and *Hidden Treasures: African-American Photographers in Atlanta*. Six publications have been with Arcadia Publishing, including *African-American Life in Jacksonville, Florida*; *Black Atlanta in the Roaring Twenties*; *African-American Entertainment in Atlanta*; *African-American Life in Washington, Georgia*; *Politics, Civil Rights, and Law in Black Atlanta*; and *African-American Life in East Point, Georgia*. Mason is the dean of students at Morris Brown College and pastor of the Greater Hopewell CME Church. He is married to Harmel Codi, and they are the parents of a daughter, Jewel.

One
BEFORE EMANCIPATION

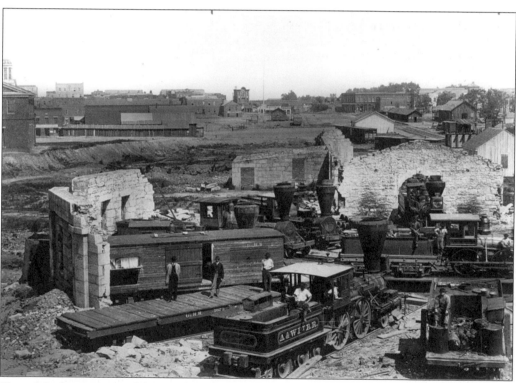

The original occupants of the area now known as East Point were Creek Indians, who resided in the area known as Fulton County. In Franklin Garrett's book, *Atlanta and Environs*, we find that a new town begins to develop at the junction of two railroads, the Atlanta and West Point Railroads. A passenger train was finished with trains to Palmetto, Newnan, and Lagrange. At the eastern terminus of the Atlanta and West Point, this new hamlet would be appropriately called East Point. A post office was established and in 1870 and the East Point Jug Company was formed. Located 6 miles from Atlanta, 97 miles from Macon, and 81 miles from West Point, this newly formed village had two churches, a school, and a steam gin.

Historian Anne Larcrom, who did extensive research on East Point and on six of the African-American churches in East Point, wrote in her document that the first people of African descent to settle in what was to become East Point, Georgia were the slaves owned by the Connally brothers. The three brothers, David, Abner, and Christopher, purchased land and settled in this area of DeKalb County in the late 1820s. The Connallys, along with Lewis Peacock, also a slave owner, were listed in the 1830 census of DeKalb County. Though few in number these people were an integral part of the Connally family experience and their names were recalled in an informal account, the *Connally Manuscript*, written nearly a century later by Mary Connally Spalding, great-granddaughter of David Connally. (Courtesy of East Point Historical Society.)

Ann Larcrom wrote in her comprehensive study that in 1866, following Emancipation, it was a difficult time for residents, black and white, in East Point. Caught in the aftermath of the Atlanta Campaign, the area's economy had suffered total disruption in the nation's Civil War. After the Battle of Atlanta, East Point, located at the junction of two railroads still supplying the Confederacy, became the focus of General Sherman's strategy to destroy all transportation lines. When Union forces found the area too heavily fortified to invade, they struck and destroyed the railroads south of East Point and the town was spared a major battle. Returning residents found shelter in the soldier's abandoned shanties. The only two structures left intact were the Connally Grist Mill and a Railroad Water Tower. But it was more than the devastation of homes and fields that confronted these survivors. They were engulfed by the massive social, economic, and political changes, which accompanied Emancipation. African-American men and women, who had previously worked the plantations as slaves, were now free. Fired up with the concept and promise of freedom, some were eager to move or claim their rights to farm the land or seek employment with the railroad. They cleared the land, planted, and harvested the wheat, cotton, and corn that sustained early settlement

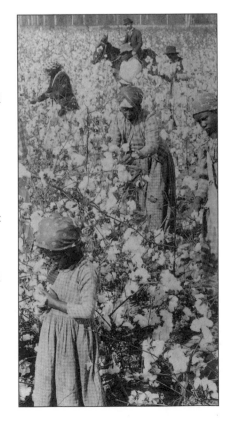

East Point grew out of land where slaves farmed and picked cotton. This old field house, which once housed slaves, was located in the rear of the home of Howard L. Carmichael. Carmichael is listed as owning slaves on the 1860 Slave Inhabitants Records. The area that would become known as the Fourth Ward, the primary residential area for African-American settlement, was a plantation owned by the Thompson family according to Bill Cooper, a longtime white resident of the area. His family had a housekeeper named Mancie who was one of the slaves from the Taylor plantation. (Courtesy of East Point Historical Society.)

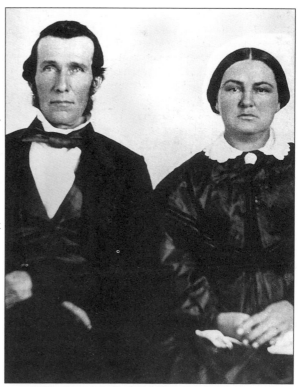

Ran Peacock, a former slave who lived in the area where East Point is located, belonged to the grandfather of Thomas W. Connally. He was born on the property of Lewis Peacock. Peacock's daughter Temperance (pictured right) married Thomas Connally and eventually became her property. Their son E.L. Connally played with Ran as a boy. In a deed recorded in Fulton County on June 26, 1884, pioneer settler Thomas Connally deeded to Jacob Connally, Sandy Dixon and Henry Mason, trustees for the East Point Baptist Church (a black congregation) in fee-simple, one acre of land adjoining the Connally cemetery to be used as a burial ground for "colored people of all denominations. . . and for no other purposes." The exact location of this church is not known unless it was the forerunner of Evans Grove Baptist, which built a church on Nabell Avenue (now Grove Avenue) in 1907. (Courtesy of East Point Historical Society.)

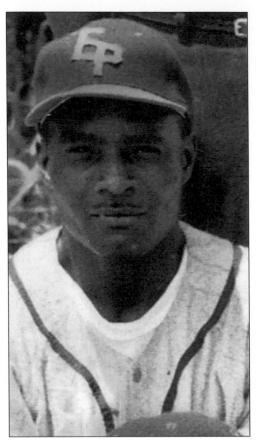

One of the oldest families in East Point with ties to the Connally family was the Strickland family. Ella Strickland was born in 1889 to Joe and Sarah Strickland. Ella's mother, Sara Strickland, was born a slave in Adamsville, but later came to live and work on the Thomas Connally place on (then) Chattahoochee Avenue. Another brother, Perry Joseph Strickland, was born in 1892. He joined Grants Chapel at the age of 4 in 1896 and was a veteran of World War 1. For years he worked at the John Deere Plywood Company. His sister Sarah married Sam Roberts Sr. and was the mother of six children, Mary Elizabeth, Henry N., James, Harry, Sam Jr., and Frank Roberts. Samuel Sr. was the community's unofficial veterinarian. His ability to cure and heal animals was legendary. Samuel Roberts Jr. would walk his mother to work each morning before 5 a.m. when her shift started at the Piedmont Cotton Mill. Shown is Sam Roberts (in his East Point Bears uniform), who is one of the last of his generation of the Strickland Family. Sam is a walking encyclopedia on East Point's history. He was born on October 20, 1918, delivered by Dollie English, a local midwife. He attended the old East Point School on Randall Street and the rebuilt school on Bayard Street.

The family of James Meadows was one of hundreds of African-American families that migrated to East Point from rural Georgia for better work. These families settled in East Point between the early 1900s and the 1930s, finding work in the industries of the area. In this c. 1927 photograph, standing from left to right, are Ruby Monds, Charlie Meadows, and Ola Mae Jackson; (seated) Mrs. Mattie Meadows, James Monds, (in lap) James Meadows, and James Jackson. Jackson's father worked at the Hercules Powder Factory making $11.88 a week. James Meadows would hunt roots in the wood for medicinal purposes. Roots such as yellow root, sassafras, and others would be used as a natural remedy for an illness. (Courtesy of James Jackson.)

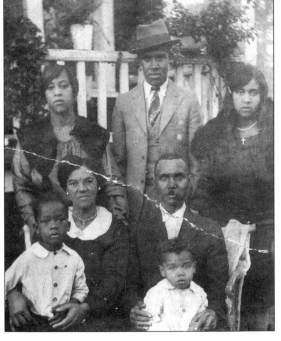

Two
FAMILY ALBUM

Mrs. Virginia "Jennie" Armstrong (center), then 108 years old, was the oldest living African-American citizen in East Point at the time of her death in 1964. She is said to have recalled the burning of Atlanta by William Tecumseh Sherman and his troops. She was born in Walton County on the Samuel Shepherd plantation during the administration of President John Tyler. (Courtesy of Charles Barlow.)

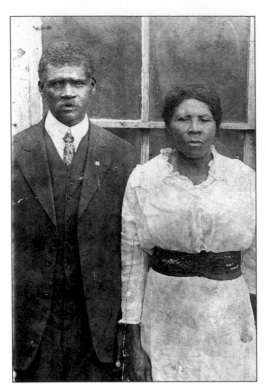

William and Missouri Price came to East Point from Forsyth County shortly after the turn of the century. William, a carpenter, built shotgun houses directly next to each other and they lived there with their only child, Mattie Price Brannon. Missouri Price did laundry for white families and was a member of Siloam Baptist Church. (Courtesy of Betty Ross.)

Joyce Ingram Woods was born in East Point and resided at 511 Georgia Avenue. She was the mother of three sons, Claude, Johnny, and Edgar. She died on March 4, 1927. (Courtesy of Evangeline Woods Gafford.)

Rosa Nixon, pictured right, and her husband Charlie owned and operated a grocery store on Holcomb Street. They resided in the Sims Town community.

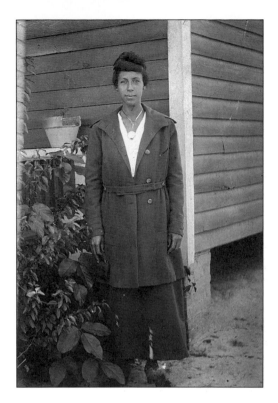

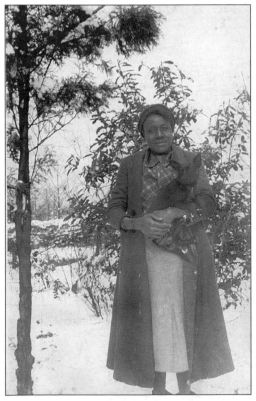

Alene Arnold worked as a domestic for the Cooper family. She is shown outside of their home in 1939. (Courtesy of Bill Cooper.)

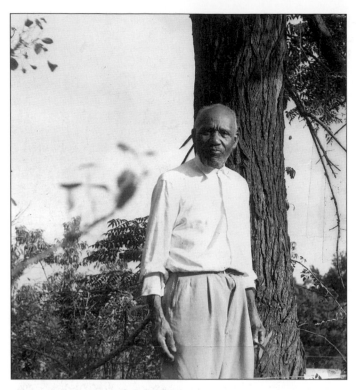

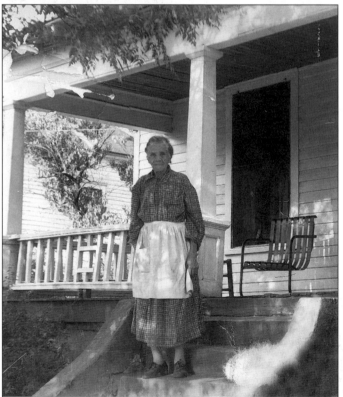

John Woodley and his wife Estella were early members of Mallalieu Baptist Church. They settled in East Point at the turn of the century and lived on Bayard Street. (Courtesy of Mildred Henderson Oliver.)

Mildred Oliver stands with her son Alfred on Bayard Street with Siloam Baptist Church in the background. Mildred Oliver, born in 1926, lived all her life in East Point. Her parents migrated to East Point from Forsyth County to live with her grandmother. She grew up in the "Junglefoot" area on Magnolia Street. Her family moved to Jonesboro, but returned around 1936 when they moved to North Street. In the house where she lived, there were two rooms on each side. They shared a kitchen and the bathroom was located outside in the back. Mildred Oliver remembers that many people went to house parties, especially if someone had a piano. The Rutherfords who lived in Junglefoot were one of the families that had a piano. Kids learned how to play the piano by taking lessons from teachers such as Eva Thomas in College Park.

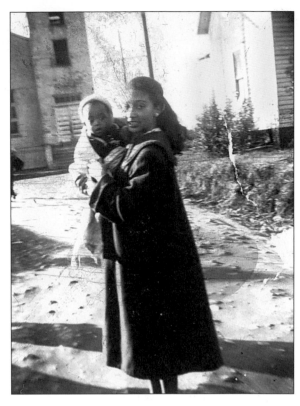

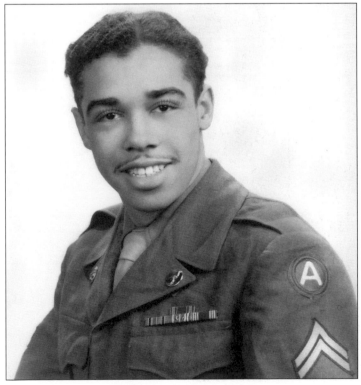

If there is a living legend in East Point then it is James Jackson, shown here in his Army uniform shortly after graduating from Booker T. Washington High School. In 1942, he left East Point to go into the military. This photo was taken in 1946 while he was stationed in Fort Devens, Massachusetts. Jackson was born in Griffin, Georgia in Spaulding County.

17

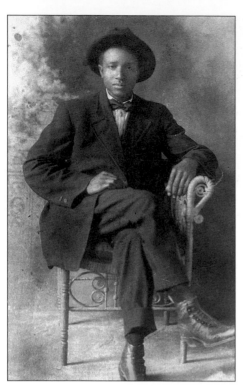

Willie Murphy is pictured in this 1920s studio photograph.

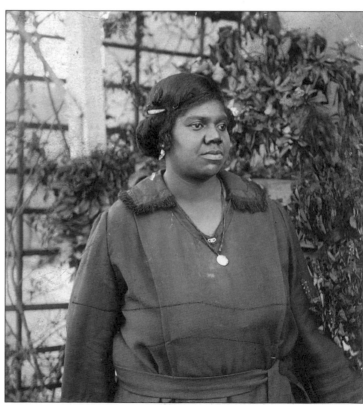

Annie Belle Murphy is shown in this photograph.

Clara Day holding Charles Mickey Lovelace (left) are pictured here with an unidentified lady. Born Clara Tucker, she worked with the Fulton County School Patrol and ran a cafe on Magnolia Street.

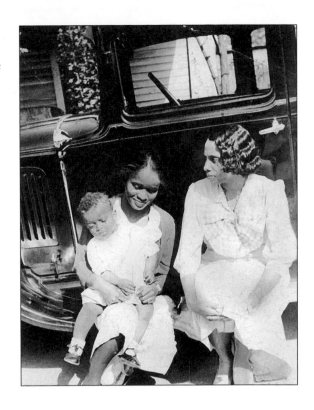

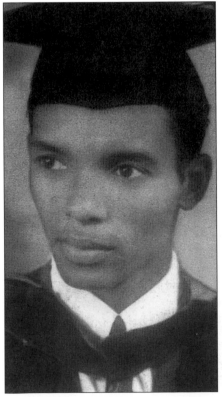

Wilson Head was one of three boys including Frank, and Marvin, and a sister Minnie, born to Evander and Evelyn Whittle Head. Minnie attended the Chadwick School and graduated from Spelman College. Wilson attended East Point School, David T. Howard Jr. High School, and graduated from Washington High School in 1935. Wilson Head obtained his first job in East Point as a part-time delivery boy for a pharmacy, working from 4 to 10 delivering goods on a bicycle that he purchased. He, along with Forrest and Charlie Green, organized early sandlot baseball teams, making their own gloves and bats out of two-by-fours. Wilson also had a tennis court behind Siloam Baptist Church and taught some of the boys how to play table tennis with wooden paddles. After spending a » year at Morris Brown College (1935–1936), he transferred to Tuskegee Institute. Shortly before his graduation in 1940, he decided to challenge the draft system. Instead of accepting a lower classification, he demanded to be given a 4E, the classification for conscientious objection to military service. Wilson became the first African American in East Point to object to joining the army, thus gaining the name by many in the community as the "Conscientious Objector."

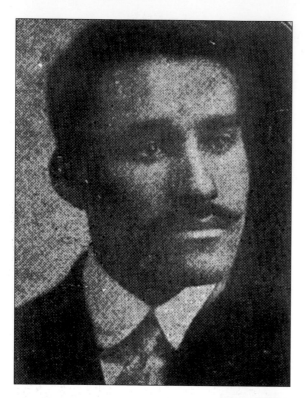

Rev. Phineas H. Head was a traveling preacher. For 27 years he was the pastor of New Hope Baptist Church in Atlanta and was widely known throughout Georgia in church, civic, and fraternal circles. He married Mariah Green and they were the parents of a daughter, Annie Mae. Reverend Head built a home on Bayard Street for his family. He enjoyed debating issues, particularly those of a religious nature.

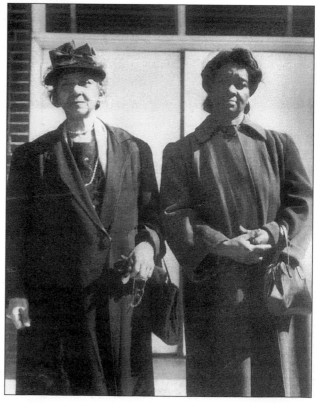

Mariah Green Head (left) was born in Upson County, Thomaston, Georgia. After attending Marshallville High School she taught in Upson County until moving to East Point. She joined Siloam Baptist Church and helped organize the Hyacinth Art Club where she served as president for 30 years. In addition, she served as president of the Cane Creek Association Women's Convention. The Mariah Head Terrace is a street named for her and is located off of Norman Berry Drive near Martel Village. She is shown with Eucilla D. Thomas. (Courtesy of Charles Barlow.)

Another matriarch of a well-known East Point family was Gertrude Green Barlow, sister of Mariah Head. She was born in Upson County and was the eighth of nine children. After living in Orchard Hill, she married Judge Barlow on January 28, 1912, and they were the parents of 10 children. The children included Coleen, Helen, Charles, Cleveland, Lafayette, Gladys, Judge Jr., and Helen. The Barlows later adopted other children. In 1929, they moved to East Point and the family attended Siloam Baptist Church. She was active in many organizations, including the Hyacinth Club and the Rose of Sharon Club. Mrs. Barlow worked many years for Jack Gray, then the owner of the Hartsfield Airfield. The Grays home was located at the end of the airfield, which was within walking distance from the Barlow home. She and her good friend, Evelyn Head, also prepared food for the airport restaurant, served the meals for the staff and airline passengers, and then cleaned the tables after passengers left. She later worked for a local physician, Dr. Gruder. Mrs. Barlow died on August 21, 1979.

Judge Barlow was a local coal and wood carrier in East Point. His children would accompany him in chopping wood to bring back and load on a truck to sell throughout the county. Barlow would take his sons to the woods beyond Bayard Street and out in the rural areas of the county near Ben Hill. They would chop wood and take it to a sawmill. They would go to the coal yard to pay for coal, which they would in turn sell and deliver. The coal was sold in 25¢ and 50¢ sacks. Most of the citizens in the community had coal furnaces and wood-burning stoves but did not have transportation. Mr. Barlow also worked for an ice company. He died in 1950.

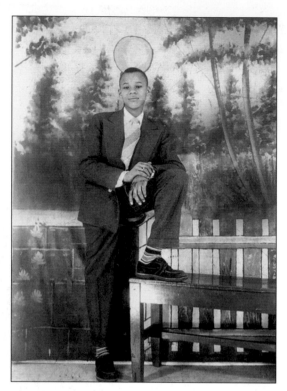

Charles Barlow was born at 721 Bayard Street to Judge Barlow and Gertrude Green Barlow on September 29, 1932. As a young man, he worked with his father in the family business of hauling and selling coal and wood. He was on the back of the truck with a friend, Walter Jackson, when his brother Cleveland was killed as the truck stalled on a railroad track going into Hapeville. Charles attended East Point High School and graduated in the second class in 1951. He attended Clark College before going into the Air Force. Barlow returned from the service and attended Albany State for two years before moving to Chicago to attend the Chicago Teachers College.

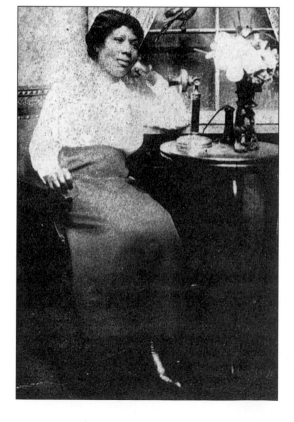

Mrs. Jessie Bell Sims was married to Bill Sims and lived in the Sims Town area of the Fourth Ward. Bill Sims operated a restaurant on Holcomb and Randall Streets in a facility once owned by Will Sewell. The Sims family had many relatives who resided in East Point and College Park.

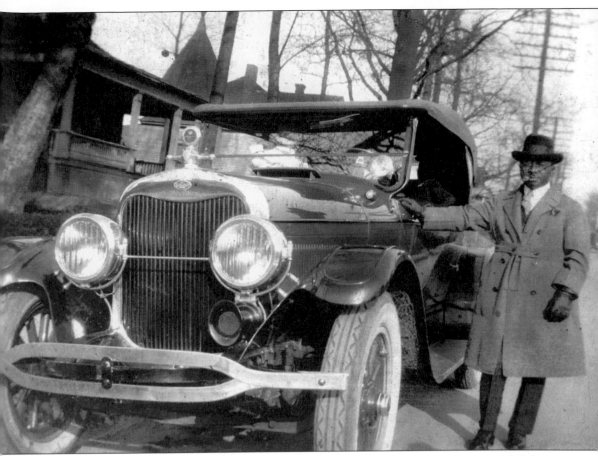

East Point gained its first black physician on June 1, 1910, when Dr. Hamilton Mayo Holmes moved to the city with his bride of one month, Pattie Lee Reeves Holmes. Dr. Holmes, a graduate of Leonard School of Medicine, Shaw University, in Raleigh, North Carolina, had been told of the need for a doctor in the East Point area. Mrs. Holmes, a graduate of St. Augustine Nursing School in Raleigh, was one of the founders and a charter member of the National Nurses Association in 1910. Upon arrival by train to Atlanta and East Point, the couple moved into a house at the corner of Georgia Avenue and Randall Street. In 1923, Dr. Holmes and his family moved to Chapel Street (Northside Drive) in Atlanta, where he built a home and a space for an office. Dr. Holmes made the acquaintance of a young pharmacist at a drug store in East Point who recommended him to a white couple in need of medical treatment. However, the law prevented African-Americans from serving whites. According to his daughter Alice Washington, the white man said, "I don't care about the law, I need some help for my wife." The couple was given directions to Dr. Holmes's house on Randall Street. Dr. Holmes, being very cautious, repeated the law to the white patient but to no avail, they wanted treatment and Dr. Holmes treated them. His early rounds were made in a buggy until he purchased a Lincoln around 1922. Wilson Head wrote that when Dr. Hamilton Holmes called on patients in East Point, it was like almost like a festival or celebration. Dr. Hamilton Holmes was active in organizing the Abram Grant Lodge No. 382, Knights of Pythias on July 5, 1912. This national fraternal order, founded in Washington, D.C., in 1864, was active in East Point for several years and included separate lodges for white and black members as well as a Junior Order.

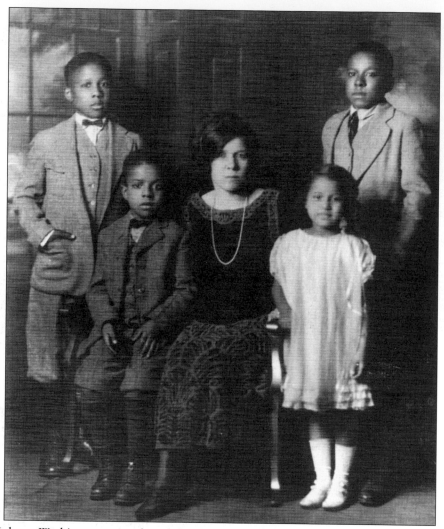

Alice Holmes Washington, seated to the right of her mother Pattie, was born in East Point on October 23, 1919. Her father delivered her because the family doctor, Dr. Powell, lived in Atlanta and, with the only mode of transportation being horse and buggy, he did not make it in time for the delivery. Although the family moved to Atlanta in 1923 when she was four years old, Alice would later return with her father, accompanying him on his medical visits to his patients in East Point. Alice remembered fondly picking plums and cherries from the trees in Miss Ann Chunn's yard and the fig bushes in the yard of Miss Roxie Farmer. After completing her studies at Oglethorpe (Lab School for Atlanta University), David T. Howard Jr. High, and Booker T. Washington High School, she graduated in 1934 and went on to Spelman where she earned a degree in education in 1938 at the age of 18. She taught in Cuthbert, McDonough, Madison, and then at her Alma Mater, Washington High, before joining the faculty at East Point High School. While taking a class at Atlanta University with her, Frank McClarin approached Alice Washington and said, "You are going to be my counselor." She didn't comment and he later came back with an application. She completed the application, he took it to the board of education, and she began her years at South Fulton (then East Point) High School in September 1951. She retired in May of 1983. Her brothers Hamilton, Oliver, Wendell, Alfred, and Fountain are also shown on this photo taken by Paul Poole in the 1920s.

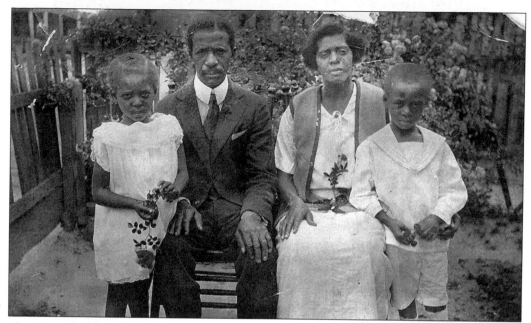

The Alexander Family—Louise, John D., Geneva, and Louis—are pictured above in the 1920s. (Courtesy of Raymond King.)

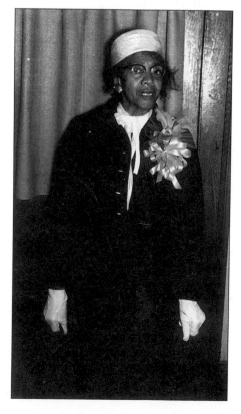

Geneva Grooms Alexander was born on September 8, 1886 in Fayette County, Georgia. She attended the old Clark University in South Atlanta, married John Dolphus Alexander in 1912, and moved to East Point in 1913. Mrs. Alexander taught school in Fayette and Fulton Counties and in the East Point Elementary School with the Adult Education program. Her son Louis "Bubba" Alexander was a World War II veteran. She was the first president of the South Fulton PTA. Her grandson Raymond A. King still resides in the family home at 3218 Magnolia Street in the "Junglefoot" area. He was the son of Eva Louise King Hector, who was also very active with the PTA. King recalled that as a child, the community was filled with older people who did not allow children to "get too far out of line." On the weekends, King remembered that there would be a "good brawl" or a heated dice game on "the Row," where police would come in and break up the illegal gambling. "Folks would scatter like blackbirds sometimes leaving their money," said King. The police would sometimes give kids a quarter from the money they confiscated. The house he grew up in had one bedroom, one living room, and a kitchen. The "outhouse" that his family used now serves as a tool shed.

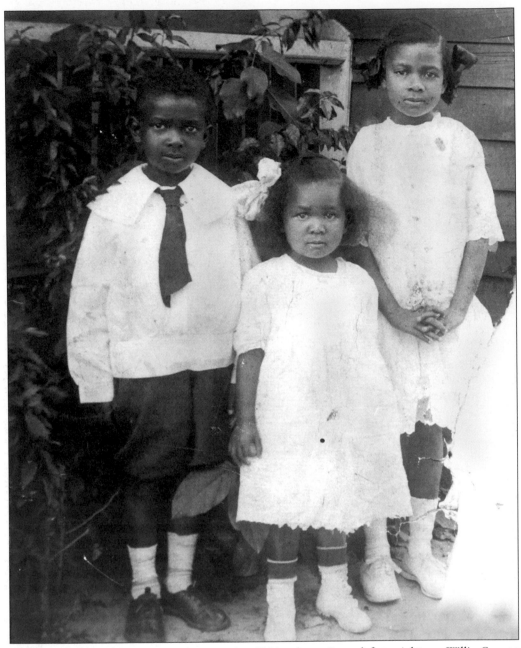

The Murphy Children are seen above in this 1930s photo. From left to right are Willie George Murphy, Lucille Margaret Murphy, and Lydia Murphy.

Mrs. Arno M. Bennett Woods was an active member of the Hyacinth Social Club and Siloam Baptist Church. The Jonesboro, Georgia native was born on November 3, 1889, to Benjamin and Tallulah Bennett. Benjamin Bennett came to East Point from Fayetteville, Georgia and helped to build the city's steel plant. Arno attended Clayton County pubic schools and the Dermis Cura Beauty College where she graduated on July 8, 1908. She married Edgar Woods and they were the parents of William, Benjamin, Leon, Roland, Melvin, and Evangeline. For more than 67 years, she was active with the Arena Chapter No. 29 of the Order of Eastern Stars. She died just a few months short of her 100th birthday on March 29, 1989.

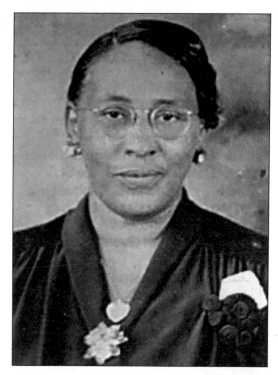

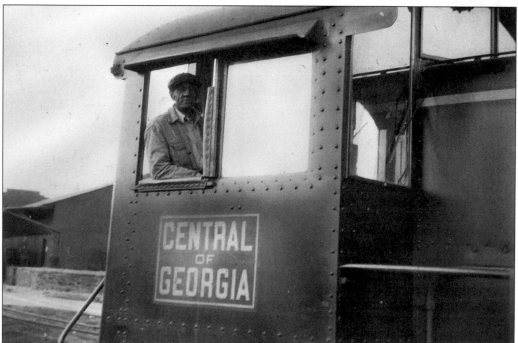

Edgar Woods Sr., the patriarch of the Woods clan, worked for more than 55 years as a railroad and yard firemen for Central Railroad. His father was born in Ringold, Tennessee and came to East Point in the 1800s, helping to construct the old Grant Chapel AME Church. The younger Woods was born in East Point on September 30, 1889; he died in 1963.

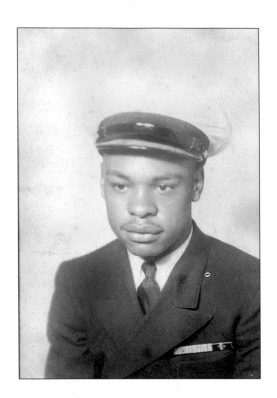 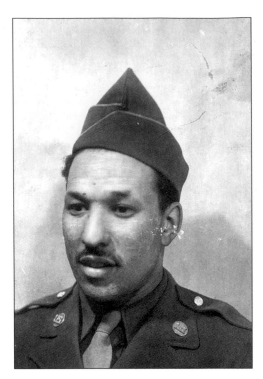

Edgar and Arno Woods saw all of their sons and daughter serve their country in the military. They are, clockwise from top left, Ralph Woods (Navy), William A. Woods (Army), Roland H. Woods (Army), and Leon J. Woods (Army). (Courtesy of Evangeline Woods Gafford.)

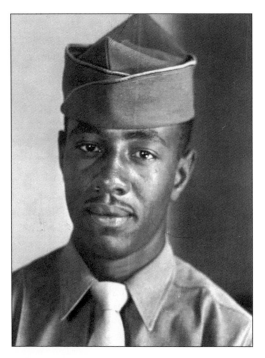 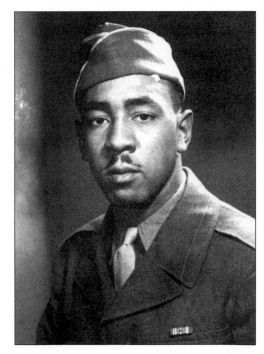

Benjamin Marion Woods poses with his military firearm while stationed in the North Pacific. (Courtesy of Evangeline Woods Gafford.)

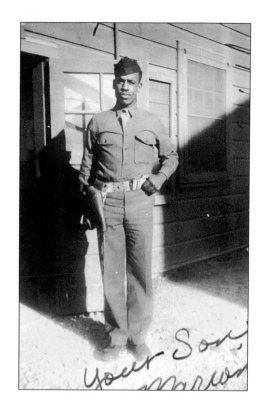

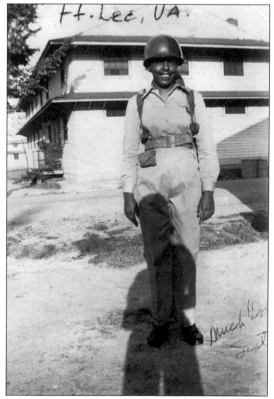

The lone sister of the Woods clan, Evangeline Woods was 21 years old when she volunteered and enlisted in the U.S. Women's Army Corp during the Korean Conflict. She was sworn in by Commanding Officer Maj. Jack R. Glenn in 1951 and was stationed in Fort Lee, Virginia. (Courtesy of Evangeline Woods Gafford.)

Mattie Brannon (seated) was the daughter of William and Missouri Price. Mattie and her husband were the parents of three children, Ethel, Iona and Sterling. Standing in the 1940s photo above are (clockwise, from left to right) Ethel Trice, Bettie Trice Ross, and Ronald Ross. There was not a student at South Fulton that did not patronize Mrs. Ethel Trice's place for snacks before and after school. Her place was a popular hangout for kids during the 1950s. Ethel Price Trice was born in Forsyth, Georgia. Her father was from Talbot County. Ethel and her sister did domestic work for the Wright and Chambers families, respectively. Ethel's daughter Betty Trice was born in 1925. Her great-grandfather worked at the White Hickory Mill. The Price and Brannon families had deep ties to their community in East Point as entrepreneurs.

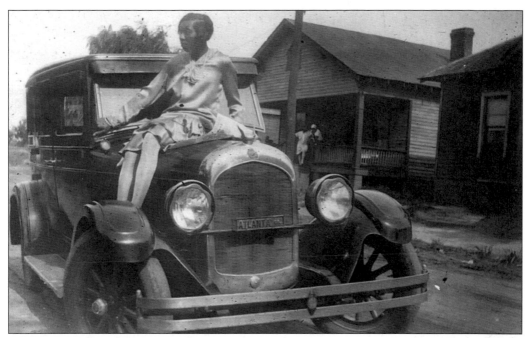

Ruby Louise Chunn had a distinguished career in education in East Point and the city of Atlanta. She was born the fourth of five children to John and Nanny Long Chunn in 1903; her family settled in East Point in the late 1800s. Her mother Nannie Long Chunn was born in McDonough and was a descendant of Jefferson Long. Nannie's sister was the mother of Rev. Martin Luther King Sr. and her brother produced the offspring of Ralph Long, a well-known and respected educator in Atlanta, whose daughters Carolyn and Wilma were active in the Student Civil Rights protests of the 1960s. Nannie Long Chunn died on September 23, 1923. (Courtesy of Pat Hurd.)

Maggie Patricianne Hurd would grow up to have a distinguished career in education. The daughter of O.J. and Ruby Chunn Hurd, she received her doctorate degree in biology at Atlanta University. Dr. Hurd, a 1958 graduate of South Fulton High School, was one of several in East Point's black community to receive advanced degrees in academic study. She worked with the Fernbank Science Center in DeKalb County, where she was an instructor in electron microscopy. She has lectured in this country and abroad in her field of science. Her achievements have made her a credit to the East Point community.

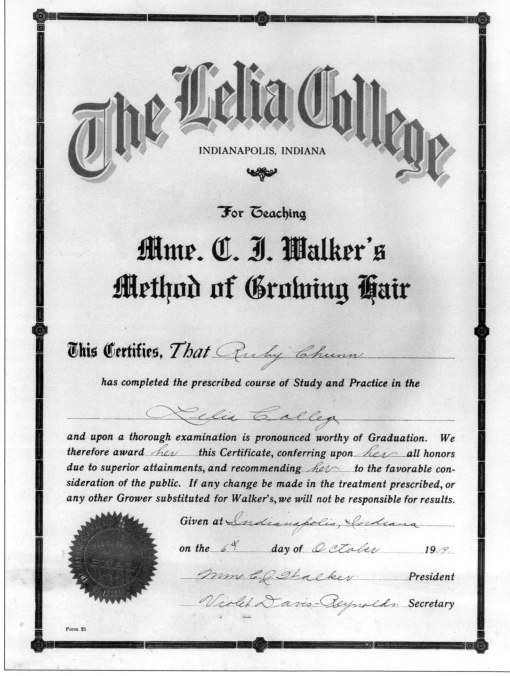

The Lelia College

INDIANAPOLIS, INDIANA

For Teaching

Mme. C. J. Walker's
Method of Growing Hair

This Certifies, *That* *Ruby Chunn*

has completed the prescribed course of Study and Practice in the

Lelia College

and upon a thorough examination is pronounced worthy of Graduation. We therefore award *her* this Certificate, conferring upon *her* all honors due to superior attainments, and recommending *her* to the favorable consideration of the public. If any change be made in the treatment prescribed, or any other Grower substituted for Walker's, we will not be responsible for results.

Given at *Indianapolis, Indiana*

on the *6th* day of *October* 19*19*

Mme C. J. Walker President

Violet Davis-Reynolds Secretary

Form 21

Before she began her illustrious career in education, Ruby Chann Hurd trained in the area of hair care. She was awarded this certificate from Leila College just several months after Madame C.J. Walker died in Indianapolis, Indiana on May 25, 1919. It is not known whether Ruby completed the course through a correspondence program or whether she traveled to Indianapolis to be trained in the Madame C.J.Walker method of growing hair. (Courtesy of Pat Hurd.)

MOREHOUSE COLLEGE

ATLANTA, GEORGIA

Summer School Certificate

This is to Certify, That *Rubye L. Chunn*

has satisfactorily completed the full course of three summers,

as prescribed, and is entitled to this certificate.

Date *July 24,* 192 *5*

Ruby Chunn received this Summer School certificate from Morehouse College in 1925. That same year the State of Georgia awarded her a Provisional General Elementary Teacher's Certificate. The top right-hand corner of the certificate had "Negro" listed on it. Ruby taught at the Hapeville Elementary School for many years. Each year she would receive a contract from the Fulton County Board of Education. In 1946, while working at Hapeville, she was a paid a salary of $105 per month for a 12-month period.(Courtesy of Pat Hurd.)

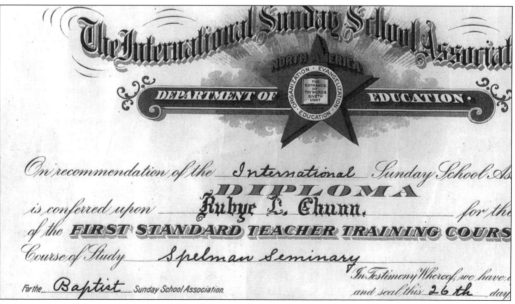

The International Sunday School Associat...

DEPARTMENT OF EDUCATION

On recommendation of the *International* Sunday School As...

DIPLOMA

is conferred upon *Rubye L. Chunn* for the...

of the **FIRST STANDARD TEACHER TRAINING COURS...**

Course of Study *Spelman Seminary*

For the *Baptist* Sunday School Association. In Testimony Whereof, we have...
and seal this *26th* day...

Ruby Chunn also completed the standard training teachers course at Spelman Seminary in May of 1922 as a part of the International Sunday School Association. (Courtesy of Pat Hurd.)

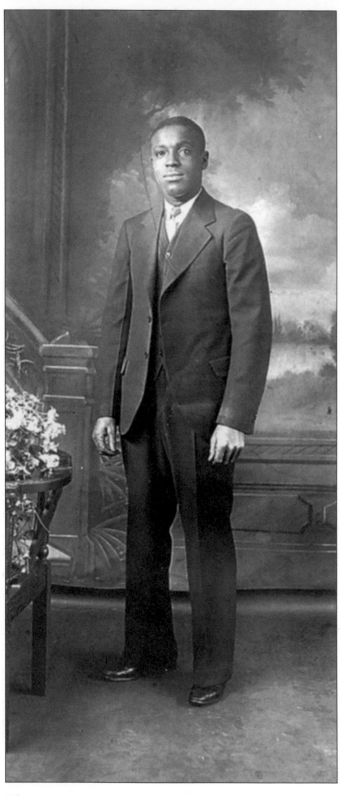

Oscar James Hurd was one of the most respected and beloved men in the African-American community in East Point. He was born in 1903 to sharecropper parents Mark and Savannah Head in Kossuth, Mississippi. His education was completed in Kossuth, where he graduated from Scale High School. When he moved to Atlanta around 1925, Oscar attended Morehouse and Clark Colleges and joined Siloam Baptist Church. As the Depression hit in the late 1920s, he found work on an ice truck. Later he joined the Southern Railroad as a pullman porter. Quite an industrious man, he also worked as a salesman for the Atlanta Life Insurance Company. Hurd organized the first Little League baseball team in East Point, was active in voter registration in the late 1950s, and was instrumental in the accomplishments of the South Fulton Booster Club, which he helped charter in 1959. He helped develop a transportation service for the citizens of the community, prompted by the lack of transportation for the black community from the Atlanta Transit Authority. He established Friendly People's Busline in 1952, and drove school buses for Fulton and Clayton Counties. Hurd was so well connected that when Sergeant Shriver was honored in Atlanta on August 26, 1965, at the Americana Hotel, he received, via Western Union telegram, an invitation to attend. (Courtesy of Pat Hurd.)

On December 19, 1937, Ruby Chunn married Oscar Hurd and two children were born to that union, a son (stillborn) and a daughter, Maggie Patricianne. Ruby Chunn Hurd began her teaching career in Fulton County at the Randall Street School and later taught at the Hapeville Elementary School. After Hapeville was incorporated into Atlanta, she transferred to E.A.Ware Elementary School until her retirement in 1965. (Courtesy of Pat Hurd.)

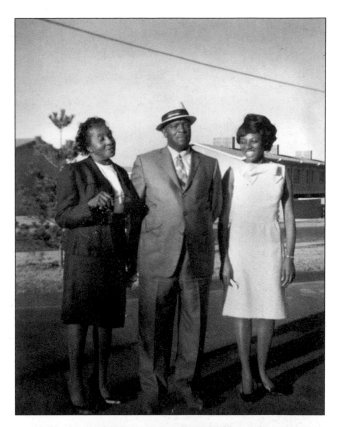

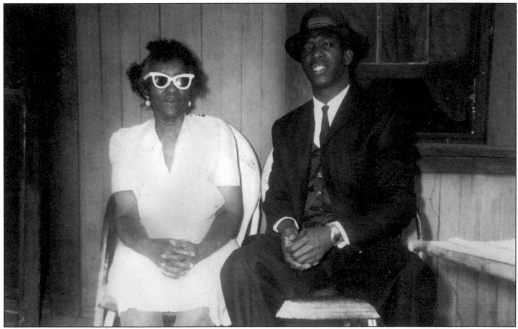

Harold Hearn is shown with his mother on the front porch of their home at 302 Georgia Avenue. (Courtesy of Harold Hearn.)

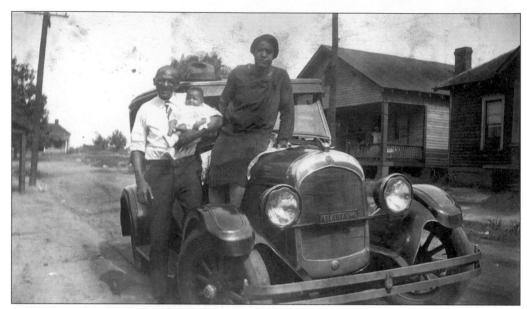

Pictured are Frank Chunn and his wife, Mable, as they posed with their automobile. Chunn was employed as a railroad fireman. He was born in 1887 and died in 1938. They were the parents of one daughter, Margaret. (Courtesy of Pat Hurd.)

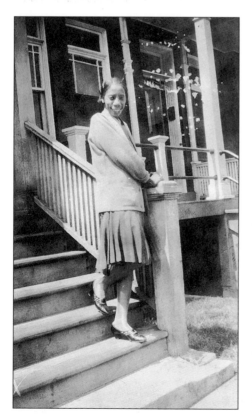

Ann Meredith Chunn was born in 1905 to John and Nannie Chunn. She attended school in East Point before going to Morris Brown for the teacher-training program in 1924. She completed her studies at Atlanta University, where she received her diploma in 1926. Her first teaching position was in Gainesville, Georgia from 1927 to 1929. She returned to the Fulton County School System in 1920 and taught until 1951, and then transferred to the Atlanta Public Schools. She retired from E.P. Johnson Elementary School in 1968. Ann Chunn died on March 12, 1988, at the age of 80. (Courtesy of Pat Hurd.)

Carrie Chunn Hunt, the oldest of the Chunn siblings, spent her working years as a domestic and was employed by several Jewish families in Chicago, where she moved after she left East Point. She was born in 1898 and died in 1959. (Courtesy of Pat Hurd.)

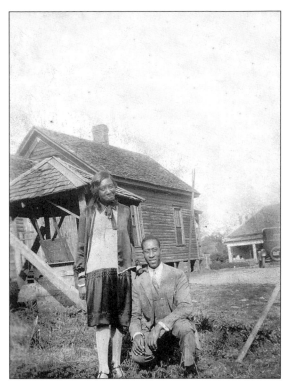

Dr. Walter Dorian Chunn is pictured above beside his car. Chunn left East Point at an early age and lived in Texas. He attended Meharry Medical School in Nashville, Tennessee where he completed his degree in dentistry. He was married to Laura Roberts. Dr. Chunn moved to Chicago where he operated a successful dental practice. His family often recalled his generosity before his death in 1974.

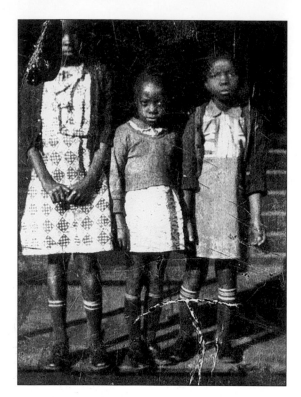

The Caldwell sisters are pictured on the steps of their home. From left to right are Mary, Willie B., and Annie Mae. The sisters resided with their parents on Barnett Street. (Courtesy of Willie B. Caldwell.)

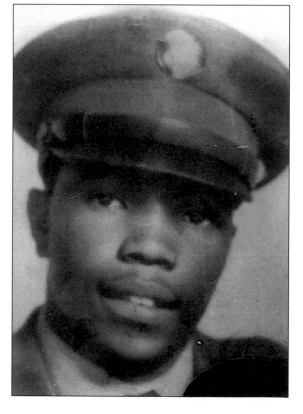

Joseph Collins Jr. was killed in combat duty in Korea on June 25, 1953. Collins was born in East Point to Mr. and Mrs. Joseph Collins and had graduated from South Fulton High School in 1952. Before he left to serve his country, he married Irene Milner and they had one son, Perry Collins.

Three
WHERE WE LIVED

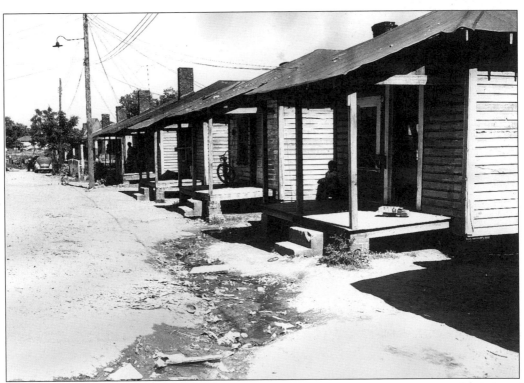

"Finally all preparations were completed and my father rented a truck and with the help of friends, he loaded the furniture and other belongings and prepared to drive several miles to East Point in suburban Atlanta. The necessary arrangements for our new home had been made by one of our relatives," said Wilson Head, in a 1995 interview. This segregated housing pattern presided in East Point until after World War II when the critical shortage of homes began to cause a shift north of Washington Street toward Cleveland Avenue. Pictured is the Oil Mill Row section from Bayard Circle looking south in 1957. (Courtesy of East Point Historical Society.)

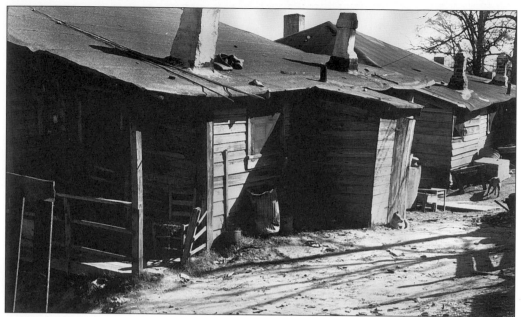

With the opening of the Furman Farm Improvement Company, African Americans were able to find industrial employment and many moved from rural areas to East Point to work in fertilizer mills. The location of the Furman Plant, adjacent to the Central of Georgia railroad tracks at Taylor Avenue, was the cause of a gradual shift in black housing patterns. Previously, African Americans had lived near whites in neighborhood enclaves dispersed throughout the city. As East Point became industrialized, companies began to erect rows of dwellings on unpaved streets near the mills. These shotgun shanties were rented to black employees who found no option but to live near the source of their employment. (Courtesy of East Point Historical Society.)

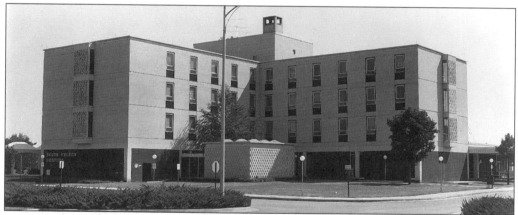

There were several pockets of African Americans throughout the Fourth Ward of East Point, many of them residing in areas such as Grabball and Blakesville, which was the area located south of Cleveland Avenue on the site of the present South Fulton Hospital (above). Some of the old families of that area were the Towns, the Shafers, and the Thompsons. There were about 15 to 20 families and 7 to 8 double tenant homes according to Sam Roberts and James Jackson. Charlie Green and R.A. Tanner farmed land in the area Most homes had a private bath with a tub. Every Monday morning, Mr. Tinch and Joe Jenkins would collect the waste. One could smell them coming down the alleys.

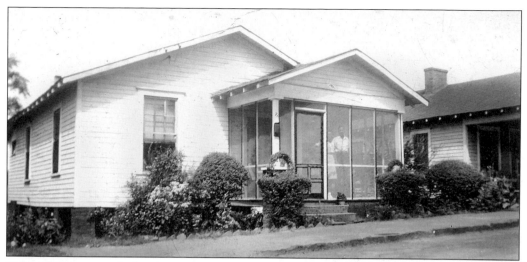

Holcomb Street was the business sector of the community. Shanghai and Newtown bordered the areas and "Junglefoot" was beyond Central Avenue and consisted of streets such as Magnolia and Cherry. Randall Street residents and businesses included Dr. Hamilton Holmes, Alston Funeral Home, John Fallen Barber Shop, and Scrap Glass. Shantyline was a small area where Tri Cities High School is now located and, at one time, a small African-American community existed. It was located near the Central Georgia Railroad. Sims Town was located south of Bayard Street where Calhoun and Bell Street were located. Pictured is the Willingham Home located in the "Junglefoot" area of East Point. Some of the families living in Junglefoot during the 1930s and 1940s included the Tuckers, Reddens, Thrashers, Hudsons, Joneses, Days, Bushes, Westbrooks, Lemons, Fosters, Tolberts, and Nixons, recalled Raymond A. King, who grew up on Magnolia Street in the area.

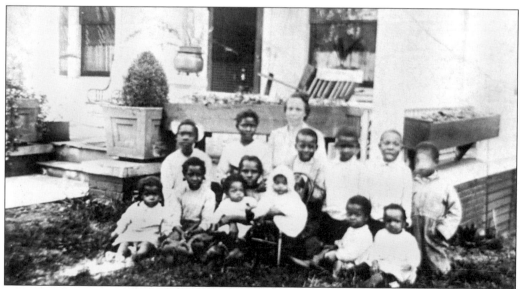

Mrs. Pattie Reeves Holmes is pictured in the yard of her home at the corner of Randall Street and Georgia Avenue. In the *c.* 1920 photo above, she is pictured with her daughter Alice (baby in chair) and her sons, Hamilton Mayo Holmes and Alfred Fountain Holmes. (Courtesy of East Point Historical Society.)

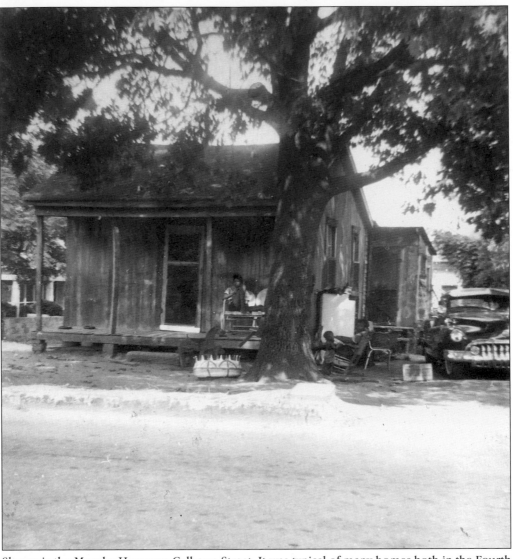

Shown is the Murphy Home on Calhoun Street. It was typical of many homes both in the Fourth Ward and the rural areas of East Point where there were scattered African-American families. In one rural area of East Point, now the site of Word of Faith Church on Ben Hill Road and near a sprawling subdivision, the Braswell family lived literally in the woods surrounded by other houses. The family moved to East Point from Hapeville during the time of the airport expansion. They moved to the property of R.N Nesbit, a white plumber. They lived at 2476 Hogan Road near Ben Hill Road and what is now Orr Drive. The house was actually behind a fence near the City Dump. When the fence was closed, it was still a mile from the house to the fence. Mr. Braswell was a plumber's helper. On the land, the family raised animals. They had running water, but no electricity and had to heat water for baths, boil clothes in a pot, and cook in a wood/coal stove. There was a fireplace in the middle bedroom of the three-bedroom house. The Braswell children and sisters had to walk seven miles to East Point Colored School and to attend Mallalieu Methodist Church. In 1958, they moved to College Park and attended Eva L. Thomas High School. They recalled going downtown to East Point to the movie theater and paying 5¢ for admission.

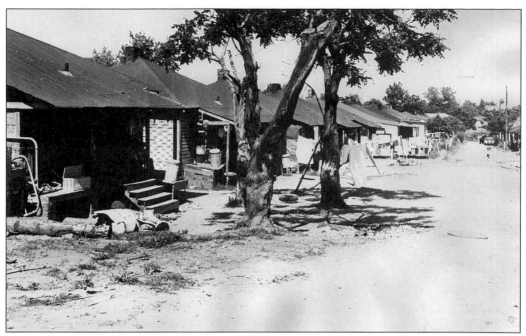

Pictured are houses on the left side of Furman Avenue. The rear of the houses faced the 100 block of Holcomb Street. Holcomb Street had numerous businesses and residences, and the following were among those listed in the 1938 directory: Rich Saul Grocery Store, E.D. Barrett Coal Co., Holcomb Street Grocery, Precious & Katie's Place, Cox Bros Funeral Home, and Grants Chapel AME Church. (Courtesy of East Point Historical Society.)

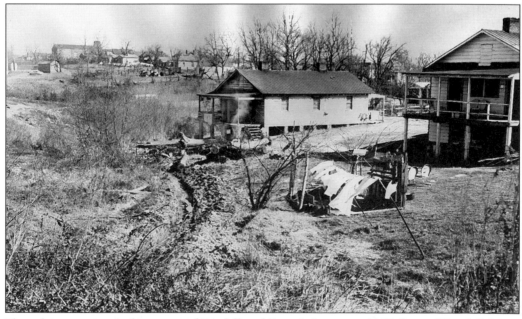

These homes were on the corner of Randall and Francis Streets, c. 1957. Parts of Randall Street were a fraction of an area called "Shanghai" which, according to some residents, was a "rough area" of the African-American community. (Courtesy of East Point Historical Society.)

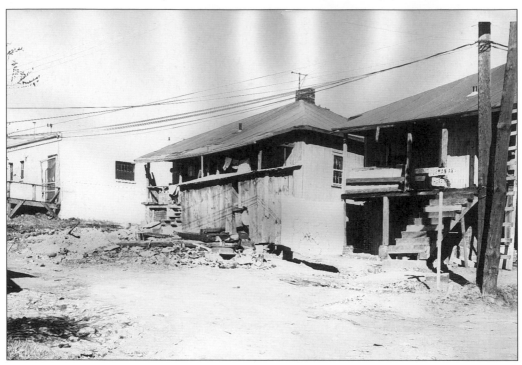

This photo provides a view of some of the conditions of the homes near the corner of Furman Avenue at Harris Street. (Courtesy of East Point Historical Society.)

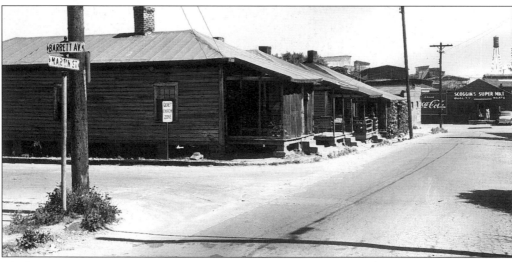

The homes above were located on the corner of Barrett Avenue and Martin Street, *c.* 1958. The Caldwell family lived at the home next to the Scoggins Grocery store on the corner. Some of the families living on Barrett Avenue according to the 1938 City Directory for East Point were as follows: William Hill, Talmadge Benjamin, Emma Smith, Charles P. Ponder, Joseph Reid, Robert Fuller, Grady Taylor, Richard Rice, Neriah Missionary Baptist Church, William Goodwin, Oneada Jacob, William Shepherd, Bertha Slan, Gladis Stanley, Fannie Howard, Fannie Sewell, James Taylor, Mattie Madison, Gertrude Williams, Eliza Jackson, and John Cooper. (Courtesy of East Point Historical Society.)

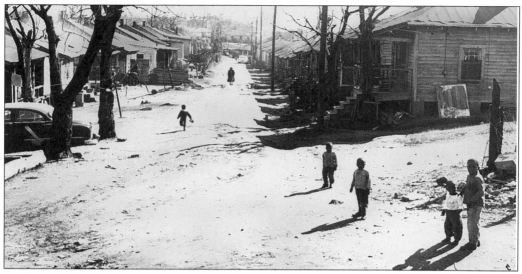

This is a full street view of Barrett Street, *c.* 1956. A few of the families that resided on Barrett during the late 1930s included William Hill, Talmadge Benjamin, Emma Smith, Charles P. Ponder, Joseph Reid, Robert Fuller, Grady Taylor, Richard Rice, Neriah Missionary Baptist Church, William Goodwin, Oneada Jacob, William Shepherd, Bertha Slan, Gladis Stanley, Fannie Howard, Fannie Sewell, James Taylor, Mattie Madison, Gertrude Williams, Eliza Jackson, and John Cooper. (Courtesy of East Point Historical Society.)

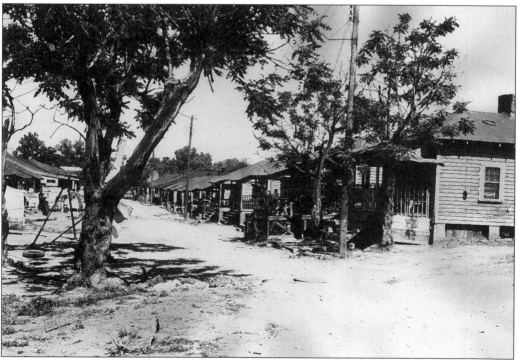

Pictured above are the homes of some of the families that lived on Furman Street. The homes, from left to right, belonged to the Dyers, the Whites, the Joneses, Mamie Reed, the Bivens, and the Pooles. (Courtesy of East Point Historical Society.)

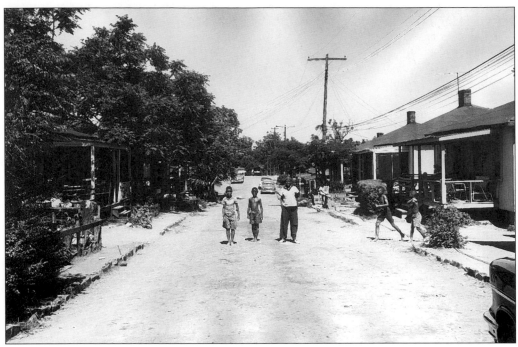

Benny Foster, Ralph High, and Jdabell Willis stand in the middle of Georgia Avenue in 1958.

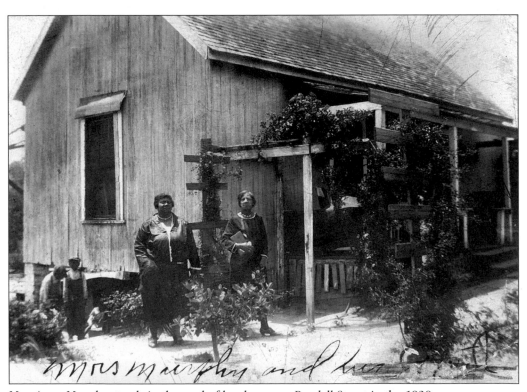

Mrs. Anne Murphy stands in the yard of her home on Randall Street in the 1930s.

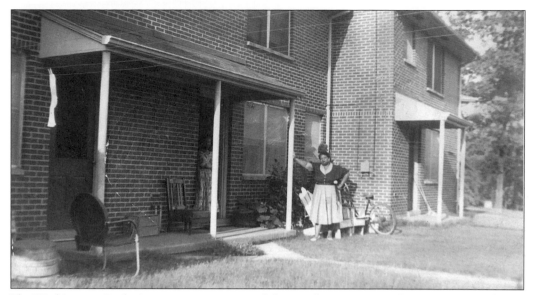

The Washington Circle Apartments, constructed during the 1950s, were located on Washington Street just a few feet from the East Point Elementary School in an area that had once been predominately white. Lucy Willis and her five children moved to the apartments in 1950. While residing there, Willis became very active in the lives of the neighborhood children. The Housing Authority appointed her chair of the East Point/Washington Circle Community Organization. A building was later dedicated to her for her work with the children and the community. She resided in Washington Circle for more than 19 years and then built a home on Georgia Avenue. Pictured above is another Washington Circle resident, Lydia Lovelace.

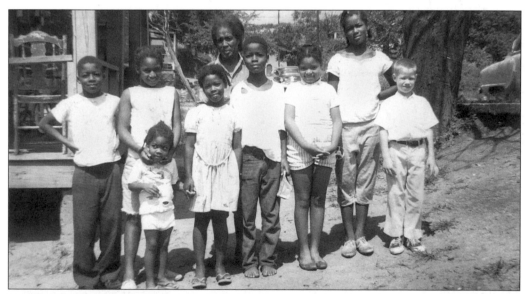

Mrs. Rosa Brooks, a domestic worker with the Cooper Family, stands in the yard of her Holcomb Street home with her children and other neighborhood children including Ronald, Donald, Reheman, Gloria, and Charlie Mae. The little white boy on the end is David Cooper, son of William Cooper, Ms. Brooks's employer. David Cooper is now the pastor of Mt. Paran Church in Atlanta. (Courtesy of Bill Cooper.)

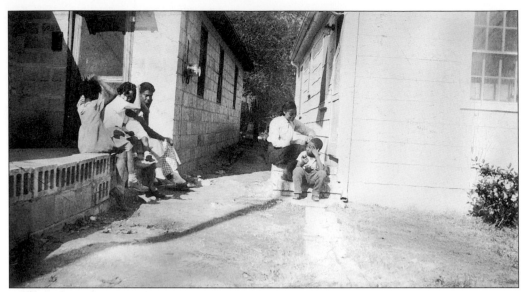

Mr. Quillian owned the duplex on Walter Street. A part of this duplex was a dry-cleaning business owned by Jesse Green. (Courtesy of James Jackson.)

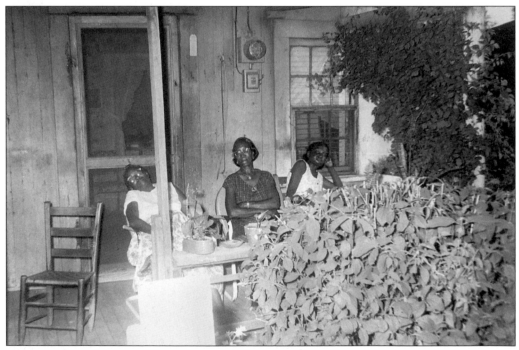

Sitting on the front porch was a familiar ritual for African Americans. Here Sarah Bennett (left) joins Cora Stinson at her Georgia Avenue home, *c.* 1956. (Courtesy of Harold Hearn.)

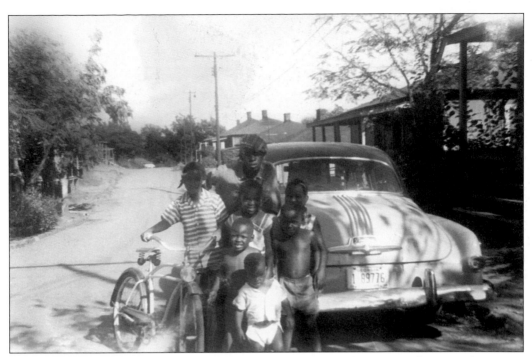

The Hearn children stood in the middle of Georgia Avenue, which was still unpaved in 1958. (Courtesy of Harold Hearn.)

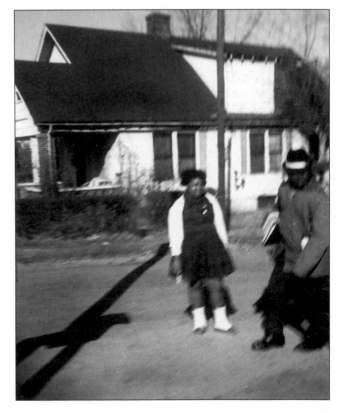

The Quillian home was located on the corner of Georgia Avenue and Randall Street. Some of the businesses on Randall Street included Halman Grocery Store No. 1, Camp's Grocery Store, Holbrook Shoe Shop, Tommie Alexander Ribs, J.R. Chambers Service Station and Cab Company, and Club Zanzibar. (Courtesy of Hattie Strickland.)

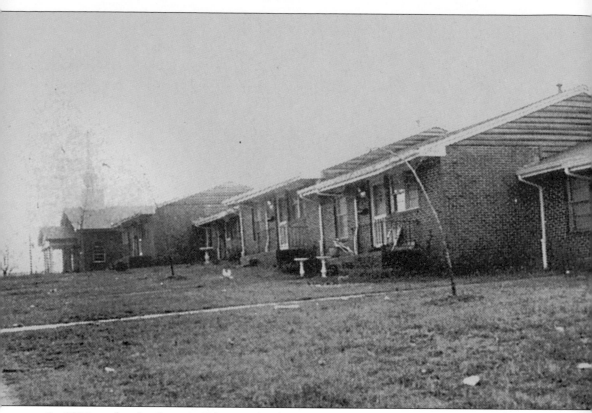

In 1957, under the Georgia Urban Redevelopment Law, East Point applied for and received a grant to finance a survey to develop plans for an Urban Renewal Project. The location was the 45-acre site on Washington Street south to the former mill industrial area. The purpose of Urban Renewal was to preserve good housing, rehabilitate blighted housing, and demolish housing that was below the guideline's minimum standards. The survey revealed 778 families who qualified under this federal/state program. The urban renewal program in East Point, which took nearly eight years to complete, cost in excess of $2 million. Included in this project were several new streets, storm drains, sewers, sidewalks, and street paving for the entire area. Long-term housing loans were made available to qualified applicants and the East Point Housing Authority completed two public housing projects—Martel Homes and O.J. Hurd. In 1965 the city was cited for superior achievement in the planning and execution of the Urban Renewal program. The O.J. Hurd Apartments (shown above) were dedicated on Sunday, January 28, 1973, at a service at Siloam Baptist Church. An open house was held at the apartment complex located on Holcomb Street as well as a reception at the Charles Green Recreation Center. The project manager of the East Point Housing Authority said that the 35-unit housing complex was a show of gratitude to a man of distinction, O.J. Hurd, and his contribution to the South Fulton Community and East Point.

For East Point's African-American community, where Urban Renewal had taken place, the program was a mixed blessing. For the younger residents it offered an opportunity to own better housing, and for the economically disadvantaged it offered quality public housing. But, for older citizens, many who had owned their own homes (though older and in poor condition) it was a crisis situation. Some had no choice but to move away, never to return, while others moved into local public housing. (Courtesy of East Point Historical Society.)

The Easons resided in their new home at 1193 Bell Avenue in the former Sims Town area. In the late 1950s and early 1960s, developers began to build sprawling and spacious brick homes down Headland Drive and on its cross streets. Subdivisions began to replace communities. The Golden Acres Development opened in November of 1962. (Courtesy of East Point Historical Society.)

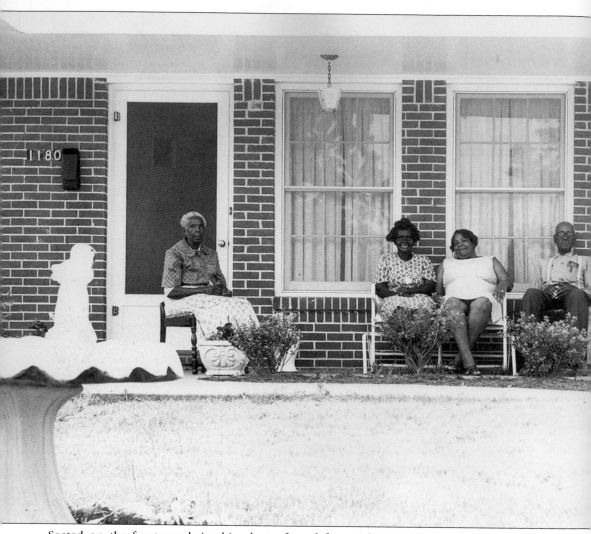

Seated on the front porch in this photo, from left to right, are Minnie Marshaman, Bertha Bailey, Galdenell Lowe, and Mr. Marshman. Many longtime residents of East Point made the transition to new homes during the Urban Renewal project of the 1960s. (Courtesy of East Point Historical Society.)

Four
SCHOOL DAYS

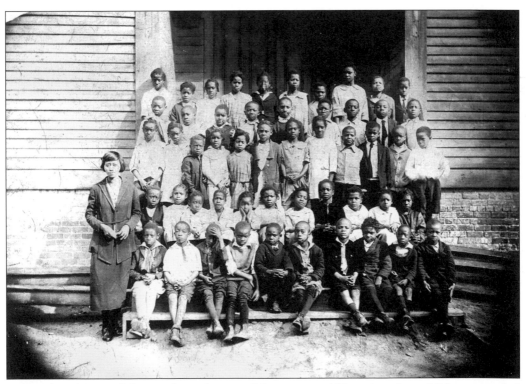

Before the 1900s and during the early part of the century, African-American children attended schools in several churches in East Point such as Union Baptist Church in the old Grabball community. In 1916 a school was constructed on Randall Street. By 1920, there were 225 African-American students attending school in the building. Professor D.H. Butler was the principal of the East Point Colored School. Many "old residents" of East Point who attended the school remembered such teachers as Mrs. Spencer, Miss Ruby Chunn, Mrs. Mary Hayes, Mrs. Sarah McCarter, and Miss Agnes Smith.

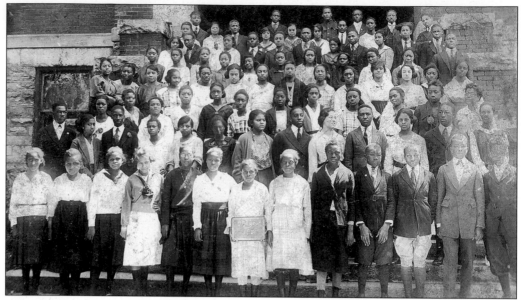

Many children in East Point were able to attend private schools at Morris Brown (above), Morehouse, and Spelman, all of which had academies for college preparatory, normal, commercial, and elementary grades. The following students were included in the 1923–1924 Morris Brown Catalogue: John Hightower (first-year, high school-college preparatory program); Mary Williams (second year, normal preparatory); Carrie L. Gray (junior in the commercial department); Rosa Murray (voice, second grade); Rosa L. Hunger (eighth grade English department); Theodore Gay and David Williams; and Mary Lovett (eighth grade). In the 1925–1926 Morris Brown College Catalogue the following students were from East Point: Willie Dixon (eighth grade); Mary Williams (fourth year high school department); Henry James (first year, college preparatory); and Blanche Gay (junior, sewing department).

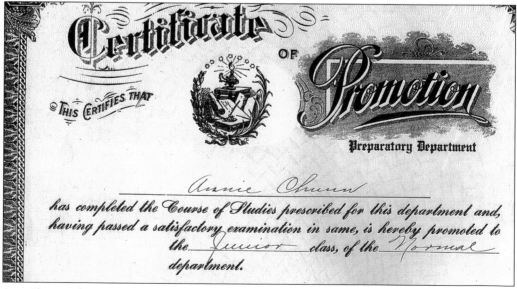

Ann Chunn of East Point received this certificate for promotion to the junior class in 1922 at Morris Brown. School president John H. Lewis signed the certificate. (Courtesy of Pat Hurd.)

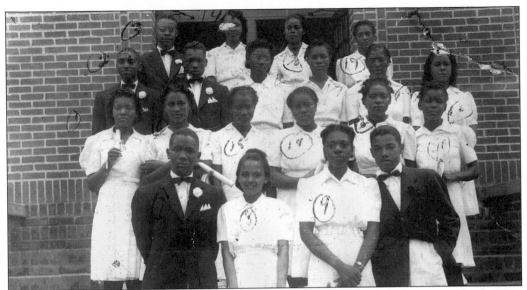

Located on the south end of Randall Street was a prolific institution for young African Americans; it was destroyed by fire in 1926. The Board of Education then acquired land for a new school but did not begin construction until 1927. That year, the East Point School System merged with Fulton County. A new brick veneer schoolhouse with 10 rooms opened in 1928 on Bayard Street at a cost of $14,857; the first principal was Mrs. T.B. Maxey. Students attended the Bayard Street School from first through eighth grades. Pictured above is the 1935 graduating class of the East Point Colored School.

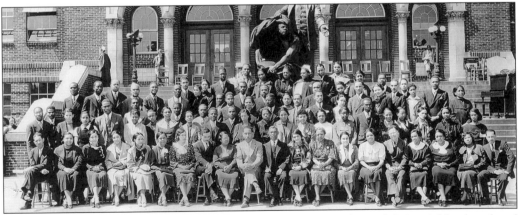

After completing the eighth grade, students had to leave the comforts of their neighborhood and venture out into new surroundings to attend Booker T. Washington High School in Atlanta. After completing ninth grade, black students in Fulton County had to attend high school in Atlanta City School, since the county had no high schools for black students at that time. The county paid tuition but transportation was an individual responsibility. Most students who attended high school in Atlanta rode the trolley to Booker T. Washington High School. Washington High School was the only high school for African Americans in the greater Atlanta area. The quality of education received by the students in the small city of East Point was highly regarded by the staff at Washington High. This is evidence by the fact that some students completing the eighth grade did not have to enroll in the ninth or the tenth grade but were automatically placed in the eleventh grade.

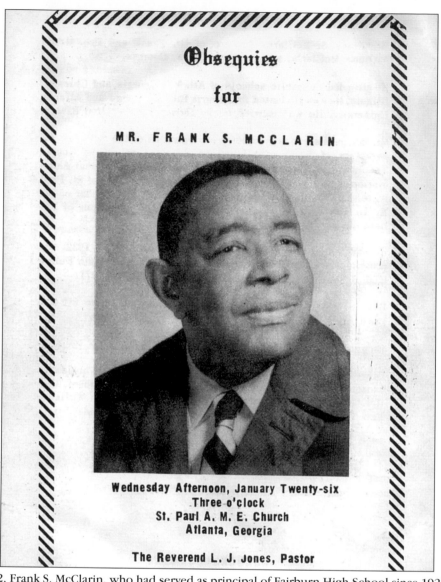

Obsequies

for

MR. FRANK S. MCCLARIN

Wednesday Afternoon, January Twenty-six
Three o'clock
St. Paul A. M. E. Church
Atlanta, Georgia

The Reverend L. J. Jones, Pastor

In 1932, Frank S. McClarin, who had served as principal of Fairburn High School since 1928, was appointed principal of the East Point Colored School, which later became South Fulton High School. McClarin came to Atlanta from Chicago according to Alice Washington. While at Morris Brown, he was active in sports. He graduated from Morris Brown in 1928 and later attended Atlanta University for graduate work. McClarin was an able and dedicated educator and a "seven-day-a-week principal." He was described as a master principal, organizer, and teacher—Alice Washington called him "a living doll." For over 40 years he inspired students, faculty, and parents with his personal commitment to excellence and his goals for community-wide achievement in academics and athletics. Some of his exceptional teachers included Ruth Parker, Mary Hayes, Ann and Ruby Chunn, and Angelyn Tatum. His former students described him as a stern disciplinarian—this was during the time when corporal punishment was the rule, not the exception. Raymond King recalled that McClarin used to "beat on [him] like he was [his] daddy." McClarin attended St. Paul AME Church on Pryor Road. His wife, Rosa Lee McClarin, was an ardent supporter of her husband's efforts at South Fulton.

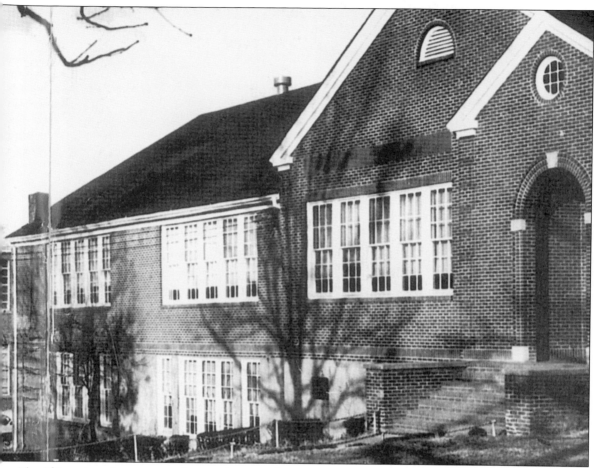

The African-American community was devastated on New Years Day in 1940 when Bayard Street School burned. It was a complete loss. The ninth grade students were accommodated at Booker T. Washington High School in Atlanta while the lower grades attended classes in local churches. Washington's principal was Prof. Charles L. Harper. Betty Ross recalled that attending the already over-crowded Booker T. Washington High was a "horrible experience." The East Point students had to stand in the hall until a classroom became available. The school board did not provide bus fare. To ride the trolley cost a nickel. Several former students recalled that many of the teachers at Washington High looked down on the kids from East Point. The school was re-built in the same location—605 S. Bayard Street—and in 1941 was re-named the East Point Colored School. Four years later, in 1945, an annex was added to the East Point Colored School which required closing the Georgia Street extension. The annex included shop and home economics classrooms in preparation for the addition of a high school curriculum to this school. Beginning in the fall of 1947, with the ninth grade, one grade was added each year until a full senior high school was in place. Many of the schoolbooks were second-hand books handed down from Russell High School. The school burned in 1948. McClarin rushed from his home in Fairburn. Several people remember seeing Mr. McClarin in tears while carrying a hammer and a sack full of nails in his hand to cover up some of the damage. The school was immediately rebuilt and the name was changed to the East Point Elementary and High School. In 1953, the name was changed to South Fulton High School.

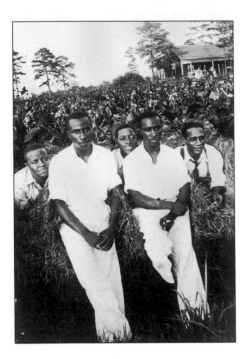

(*top left*) Pals Theodore Gay, George Sewell, and D.W. Render along with other unidentified males fraternize in an unidentified field in East Point. They were all educated at the East Point Colored School during the 1920s and 1930s.

(*top right*) Mrs. Lydia Lovelace saw all of her children educated in the East Point Colored Schools including daughter Deloris Lovelace.

(*bottom left*) Pictured is Charles Lovelace in his school days photo, *c.* 1946.

(*bottom right*) Bennie Lovelace is shown here dressed up for his school photo.

Seen here (clockwise from top left) are Bobby Lovelace, George Lovelace, Murphy Lovelace, and Evelyn Lovelace—all students of the East Point Colored School.

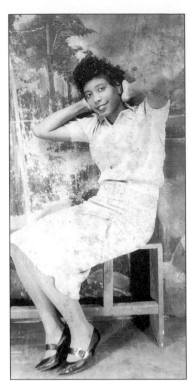

Jo Jean Taylor in her glamour-girl pose was a member of the South Fulton High School Class of 1957. Her family moved from Fairburn, Georgia to Bayard Circle in East Point. While at South Fulton, Jo Jean played basketball and entered the school's talent show doing a tap dance routine. She recalled that the kids hung out at Mrs. Ross's Store, which was across the street from the school, as well as the Zanzibar. She remembered such teachers as Gilbert, Whitman, Elder, and Washington

The East Point High School on Bayard Street held commencement exercises for its first graduating class in May of 1950. African-American students from Hapeville, College Park, Fairburn, Palmetto, and unincorporated South Fulton County attended this school. O.J. Hurd of East Point, a bus driver for the Fulton County School system, drove the bus that transported students in South Fulton County to the East Point High School. This is a photo of the first typing class at the East Point High School in 1951. Pictured on the far left end on the second row is Charles Barlow; pictured on the far right on the front row is Sanford Travis.

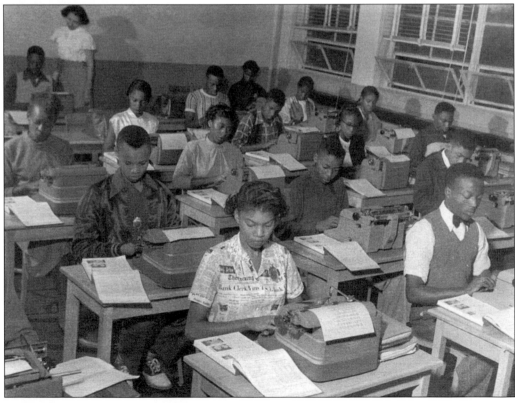

The assistant principal of South Fulton was Miss Lucille S. Harris. She was a graduate of Spelman College and lived on Raymond Street in Atlanta. Mildred Oliver remembered that the teachers would "whip you" if you misbehaved or did not memorize your assignment. They used paddles from the fourth grade on up. McClarin would whip you with a strap, she recalled. Mrs. Harris, who was her eighth grade teacher, would give you a lick if you could not remember your poems or recitations. Because she was so frightened and could not remember her poems, some of the boys in the class would take the licks for her.

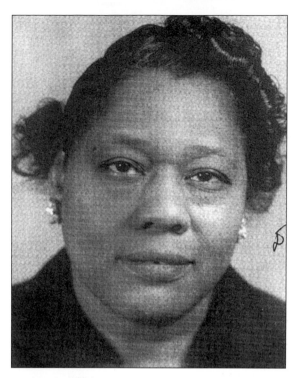

Benjamin and Harold Burks attended East Point High School and graduated in the Class of 1952. During their senior year, Benjamin, along with other students, traveled to Washington, D.C. for the annual School Safety Patrol Tour. (Courtesy of Elizabeth Hindsmen and Ben Burks.)

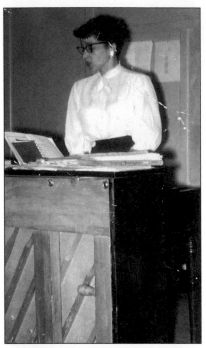

Mrs. Geraldine Moore taught music and directed the chorus, *c.* 1957. Some of the teachers at South Fulton listed in the 1958 yearbook were as follows: Clarence O. Brown, James Abrams, Frank L. Blackmon, Joyce Chambre, Mrs. Christian, Carrie L. Clements, Ruby Dye, Helen M. Elder, Mrs. Evans, William Gilbert, Hillary D. Glover, Madelyn Golightly, Elizabeth Hill, Eldridge M. Hunter, Johnnie Jackson, Henry T. Jones, William S. Lucas, Ruth Z. Lampkin, Wilbert Mclendon, Ms. Nelson, Mr. Pedro Roberts, Mr. Isaac Robinson, Mrs. Anna Jordan Scott, Mr. Virgil Scott, Mrs. Sara Starr, Mr. W.B. Thomas, Mrs. Mamie Thorpe, Mrs. Alice H. Washington, Mr. C.W. Whittaker, Miss. Wright, and Miss Anne F. Wynn. (Courtesy of Harold Hearn.)

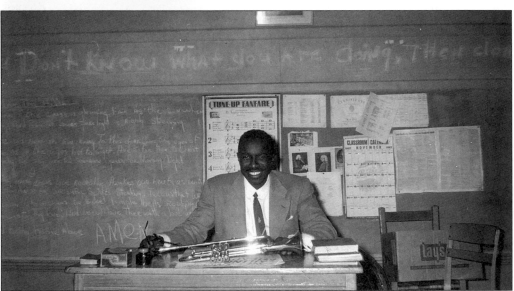

The band director of South Fulton during the 1950s was Rev. E.W. Lumpkin, shown seated behind his desk. Lumpkin, a native of Atlanta, was raised in Summerhill and graduated from Booker T. Washington High School. Following a stint in the army, Lumpkin attended Morehouse College and Interdenominational Theological Seminary and received a master's degree from VanderCook College of Music. He was a well-known music teacher throughout College Park, Fairburn, Palmetto, and East Point schools. As a minister, he served the Antioch East Baptist Church, Paradise Baptist Church, and Hunter Hills First Missionary Baptist Church. At South Fulton he organized the band and music program. Before his death in 1997, Lumpkin opened a funeral home in Covington, Georgia. (Courtesy of Harold Hearn.)

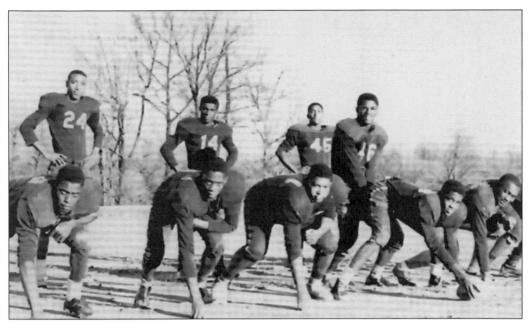

The late Melvin Bell led the South Fulton Football Team as its star quarterback, c. 1957. South Fulton excelled in athletics, producing some of the most exceptional athletes and teams in the state. They competed against most of the Atlanta high schools, including Washington, Howard, Price, and Turner. They also played Fairmont in Griffin; Ballard Hudson in Macon; Spencer in Columbus; and Lucy Laney in Augusta. Eldridge Hunter and James Abram coached all sports at the school. South Fulton won state championships in both basketball and football.

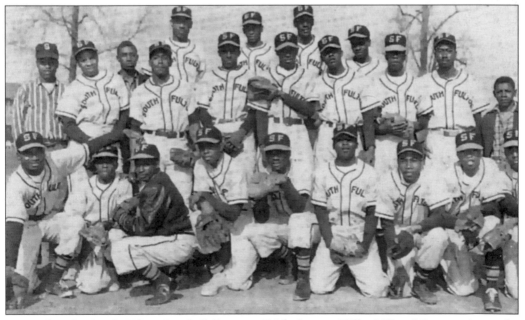

Pictured is the South Fulton Baseball Team c. 1956. George Clifford "Pops" Burnett is on the second row, fourth from the left.

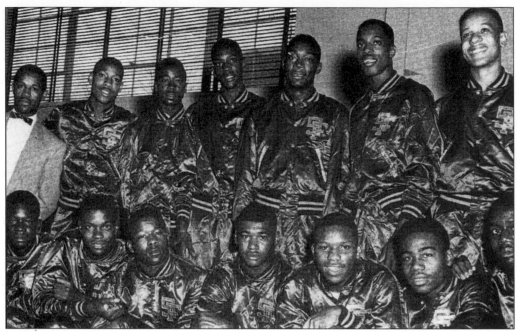

The championship South Fulton High School Basketball Team featured the Barnett Brothers in the 1950s.

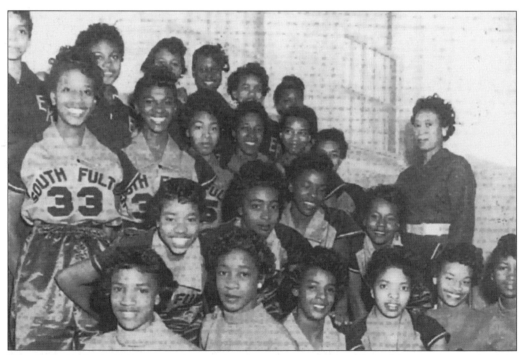

The Girls Basketball Team is shown above in this *c.* 1957 photo. They were coached by Mrs. Nelson.

This is Miss South Fulton High School 1964. (Courtesy of Betty Stokes Green.)

Athletes of South Fulton teams sport their letterman jackets. (Courtesy of Betty Stokes Green.)

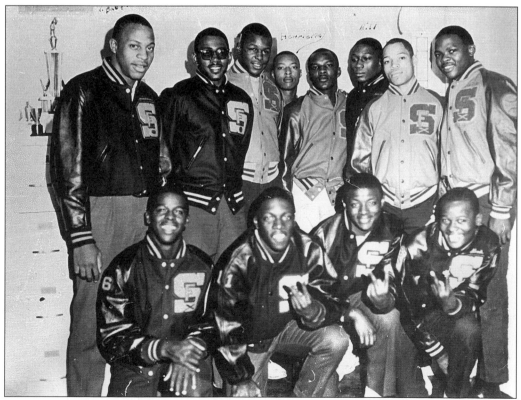

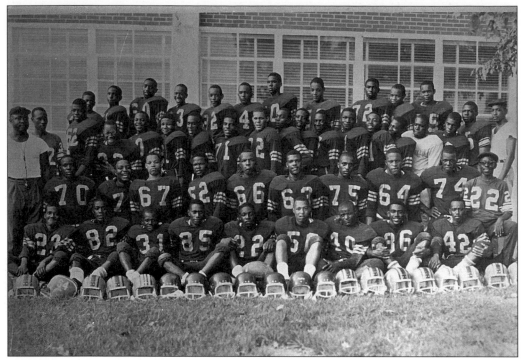

The South Fulton High School Football Team is pictured in the 1960s. (Courtesy of Betty Stokes Green.)

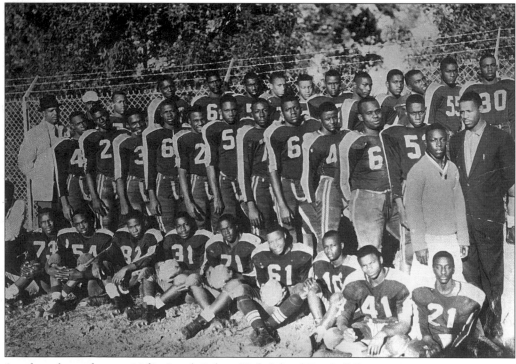

Another photo shows a 1960s South Fulton High School Football Team.

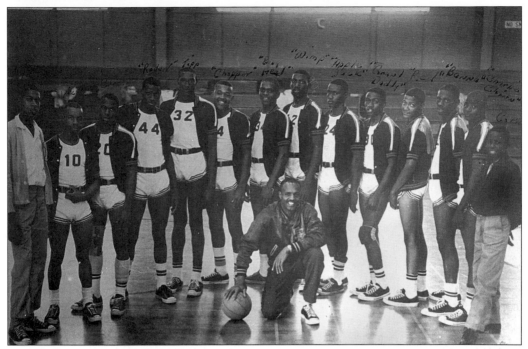

The 1964 South Fulton Basketball Team was coached by James Abrams (kneeling), a former standout basketball player at Stanton High School in Jacksonville, Florida and Morris Brown College. (Courtesy of Betty Stokes Green.)

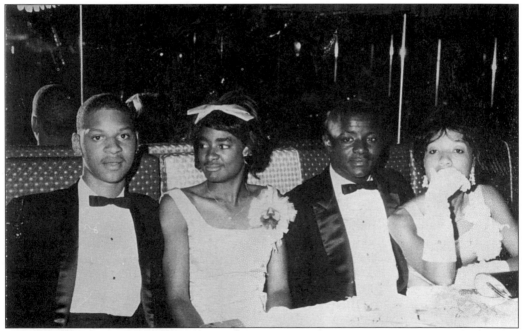

The school's prom, which was held in the gymnasium, was always a big event for South Fulton students. Pictured from left to right are Jerry Jones, Katie Cleveland Butts, Charles Green, and Betty Stokes Green. (Courtesy of Betty Stokes Green.)

The East Point Elementary School was constructed in 1953 and was located at the corner of Washington and Bayard Streets. Larry Braswell remembered such teachers as Mrs. Davie, Mrs. Ambercrombie, and Mrs. Prather. In 1990, the Atlanta chapter of Alpha Phi Alpha Fraternity arranged with the Fulton County Board of Education to acquire the school and use it as a community center. (Courtesy of the East Point Historical Society.)

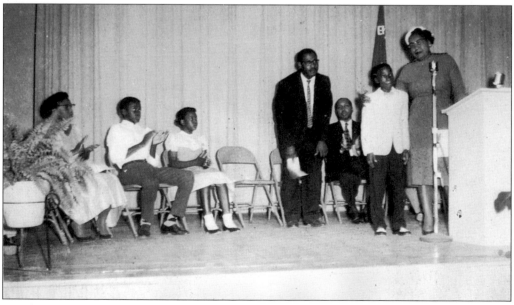

Enriching assemblies and programs were held frequently at the East Point School auditorium. (Courtesy of Betty Ross.)

Students are lined up outside East Point Elementary School (later renamed in honor of W.A. Quillian) on Washington Street in the 1960s. (Courtesy of Betty Dabney.)

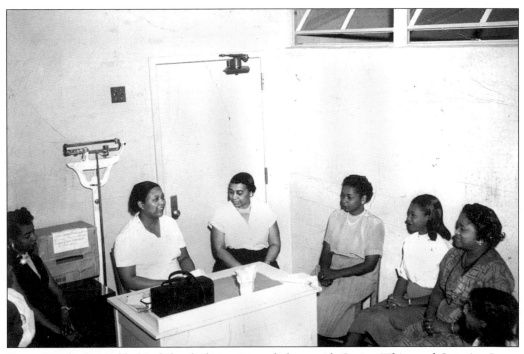

Nurse Brooks (seated behind the desk) is pictured along with Corine White and Octavius Jones in this *c.* 1955 photo at East Point Elementary School Clinic. (Courtesy of Nevador White Price.)

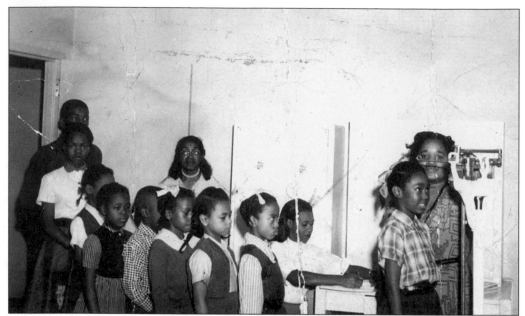

Students at the elementary school were weighed on the scale in this *c.* 1955 photo. (Courtesy of Nevador White Price.)

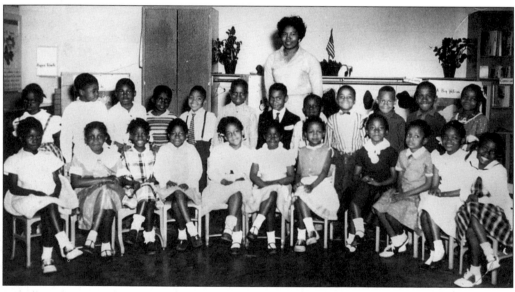

Mrs. Betty Lovett Dabney's first grade class at the East Point Elementary School is seen in this 1960s photo. Betty Lovett was born in East Point and lived with her parents and grandparents on Furman Street, and later Harris Street. Her family, like many of the residents of East Point, moved to the city from Lovejoy, Georgia. She vividly recalled her teachers at the elementary school including Mrs. Alexander, Mrs. Spencer, Mrs. Boswell, Mrs. Brannon, Mr. Neil Bridges, and Mrs. Hill. She completed her studies at the East Point High School and graduated in the class of 1952. College bound, she matriculated at Spelman College, graduating in 1956. Because of her desire to become a great educator, she obtained her masters, specialist, and doctorate degrees. Dr. Betty Dabney retired in 1995 after a fulfilling career as a teacher and principal.

Quillian Elementary School was constructed in 1961 and named for Walter Quillian. Mr. Quillian, an African-American insurance agent with North Carolina Mutual and an influential community leader, would solicit funds throughout the community to further the education of bright students. Quillian also organized the first African-American Boy Scout Troop. Some of the students who benefited from the financial aid provided by Mr. Quillian were George Sewell and Nathaniel James. James, the older brother of local historian Sam Roberts, attended Morris Brown Academy, a private high school, and graduated from Morris Brown College in 1932. After graduation, he taught in Atlanta for approximately six years before moving to Glenarden, Maryland, where he was appointed city manager and was later elected mayor. (Courtesy of East Point Historical Society.)

Frank Sims and Phil Hood, educators and Clark College graduates, were two of the first African Americans to teach at Briarwood High School. Located on Briarwood Boulevard, the school opened in 1965. Hood joined the faculty in 1966, teaching social studies and, as he says, "influencing thought and attitudes of the white students, many of whom were not used to an African-American teacher." Gerrymandering and attempts to close Eva Thomas High School in College Park sent many African-American students to Briarwood. Much dissension occurred and the school in College Park was reopened. (Courtesy of East Point Historical Society.)

By the late 1960s, many of the predominately white schools in East Point had been integrated. Russell High School, one of East Point's oldest and most prestigious schools, was integrated in 1968. Russell was later renamed Tri Cities High School. (Courtesy of East Point Historical Society.)

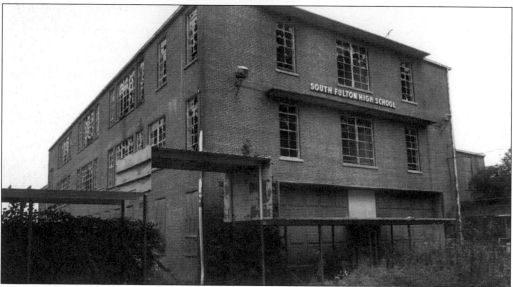

South Fulton remained a comprehensive high school until 1970. Hugh Wingo, Frank Sims, and Calvin Turner served as principals. As a result of reorganization and integration of the Fulton County School System, South Fulton became a middle school and served eighth grade students for approximately 10 years. Very early in the morning on July 5, 1982, the main part of the building was struck by lightning and burned. The damage was severe and only the gymnasium was saved. Many graduates of South Fulton earned advanced degrees and are teaching in their fields, includng Larry Taylor, a professor of history at Georgia Southern University; Rena Tally Jones, who teaches biology at Spelman College; Betty Lovett Dabney, a retired principal in the Fulton County School System; and Patricanne Hurd, who went on to Spelman College, Atlanta University, and Iowa State. Hurd returned to Atlanta University to complete her Ph.D. in biology and retired from the Fernbank Science Center.

Five
WORK AND BUSINESS

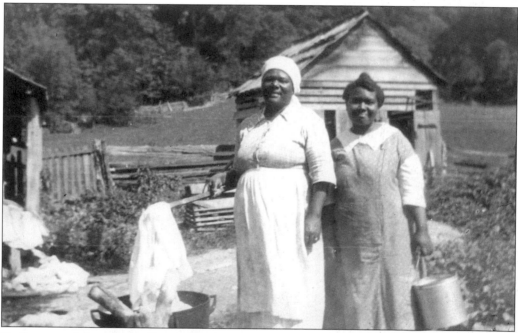

By the turn of the century, East Point's favorable location at the junction of two railroads made the city a center of industry and commerce as well as an attractive and convenient residential suburb. During the next two decades the city enjoyed great prosperity. In 1900 the population was 1,315, but by 1910 it had more than doubled at 3,682. This included 903 blacks, a percentage of 24.5. But, by 1920 when the white population had increased to 5,241, the black population had decreased to 865 or 12.7 percent of the total. Black migration to urban centers in the North and East during World War I probably accounted for this dramatic decline. The arrival of the boll weevil in the Southeast signaled the onset of a widespread farm depression that lasted into the 1920s. East Point's industrial growth, which was tied to the production and marketing of cotton, experienced a slow-down. Still, the population increased dramatically, indicating that many people, black and white, who left the farms were finding homes and work in East Point and nearby Atlanta. Many African-American women did laundry for white families in East Point.

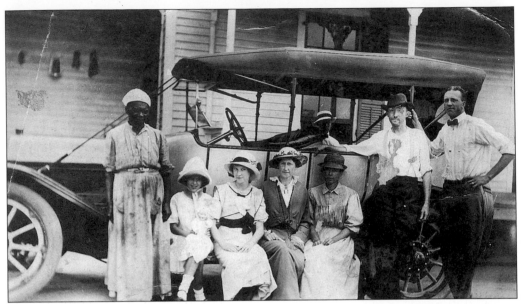

African-American women also worked as domestics in the homes of white families in East Point; this was the most common type of work for African-American women in the South. Several women in East Point also served as midwives, including Mary Jane Shannon. Pictured above is an unidentified African-American woman (far right) who was the cook for the Thompson family. Bill Cooper remembered Queen Esther Jackson and her sister, Allene, who worked as a maid and housekeeper for his family. Their mother Mancie had been a slave on the Taylor plantation in the area where African Americans would settle. (Courtesy of Barbara Brown.)

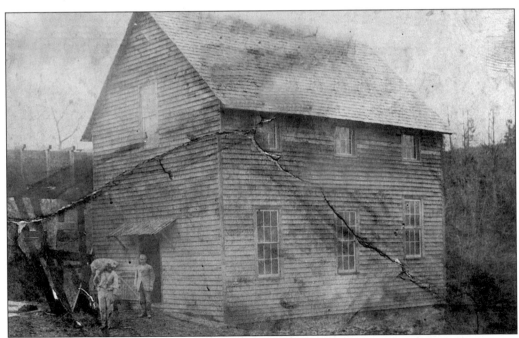

Here an African-American man hauls a bag from the gristmill of E.G. Little, located on Washington Road where the Camp Creek bridge is now located.

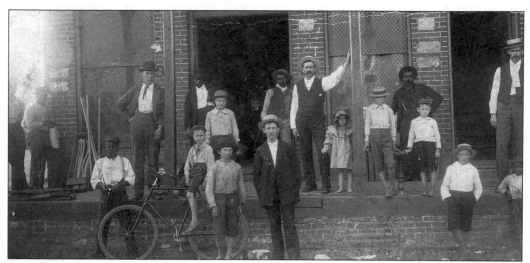

The number of black residents rose during the 1930s to 2,320. Several factors account for this sizeable increase—the opening of non-farm related industries; the large numbers of agricultural workers, white and black, who left farms to seek employment in East Point; and the proliferation of automobile ownership. Numerous African-American men worked as day laborers at stores in the city including C.Q. Tremble and Company General Store (located on Church Street). The young African-American boy standing near the bicycle in this *c.* 1897 photo was Dick Turner.

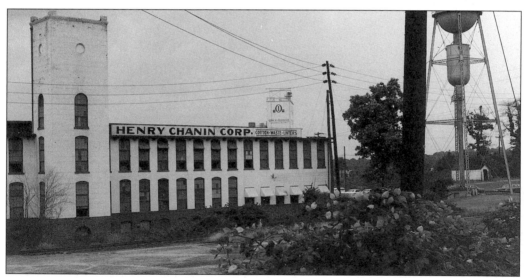

Industries in or near East Point hired many black workers, especially the fertilizer and cotton oil mills, which did not require skilled labor. Most of the mills had gins where cotton was baled and seeds separated. In the early 1930s, East Point was considered the "Promise Land" for African Americans seeking employment. Some of the businesses that provided employment were Swift Oil Mill, Gate City Cotton Mill, Furman Fertilizer, Terra Cotta Pipe Company, American Fertilizer, W.C. Merritt Lumber Company, Henry Chanin (pictured above), Hercules Powder Plant, Southern Wood Lumber Company, Marion Harper Oil Mill, Egan Cotton Mill Piedmont Cotton Mill, Atlanta Tent and Awning Company, Martel Cotton Mill, Atlanta and West Point Railroad, W.D. Hall Cotton Mill, Central of Georgia Railroad, Oneil Brothers Cotton Mill, Atlanta Utility Company, and East Point Lumber Company.

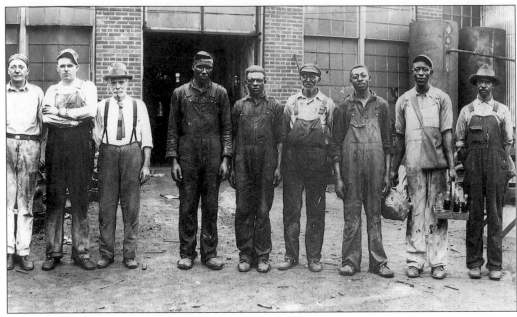

Most mills paid $12 weekly and deducted 12¢ from each check. Sam Roberts Jr.'s first job was at the W.D. Hall Cotton Warehouse picking over burned cotton. The company would buy fire-damaged bales for salvage and teenagers could get work for 20¢ an hour in 1934. "Scrap" Glass worked as a supervisor at W.D. Hall. Many of the kids in the community thought he was "rich." He worked as a machine mechanic and lived at the corner of Harris and Georgia Avenue.

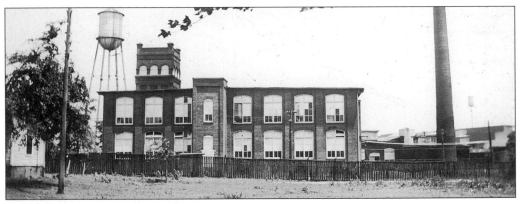

The former East Point Buggy Factory was called the White Hickory Wagon and Buggy Company and originated in the early 1900s. They made horse-drawn wagons and buggies long after the invention of the automobile. The building was sold to W.D. Hall Cotton Warehouse. Mr. Jack D. Stokes became the first African-American supervisor at the warehouse or the "strawboss." Stokes and his wife, Emma, moved to East Point from Fayetteville, Georgia and settled in a home at 316 Holcomb Street with their eight children. Mrs. Stokes was employed for over 20 years at Traders Warehouse. Pictured is the Gate City Cotton Mill. After several years, the building changed owners and the name was changed to Traders Cotton Warehouse. After Traders moved out of the building, it remained vacant until it was renovated by the city of East Point and was given a new life as the East Point Buggy Works. The East Point Wagon Works, located adjacent to the Buggy Works, was formerly known as the Oneil Brothers Cotton Warehouse. (Courtesy of East Point Historical Society.)

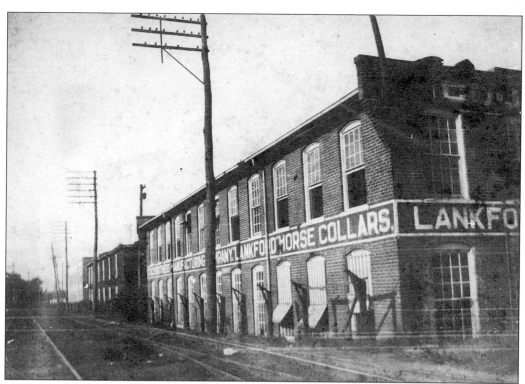

Other manufacturing companies, White Hickory Wagon, Blount Buggy Works, Couch Brothers (shown above), and Atlanta Utility Works, hired both skilled and semi-skilled craftsmen and counted a number of blacks among their employees. Coming on the heels of the agricultural recession, the Great Depression was a devastating blow to East Point. The White Hickory Wagon Company and Blount Buggy works, victims of advancing technology, closed permanently. Other industries, fertilizer and cotton mills, went on half time. Still, East Point continued to grow, attracting both white and black residents to compete for fewer jobs and limited housing. (Courtesy of East Point Historical Society.)

African-American men who worked for Couch Brothers helped to produce the Lankford Cotton Horse Collar and Blackbands. (Courtesy of East Point Historical Society.)

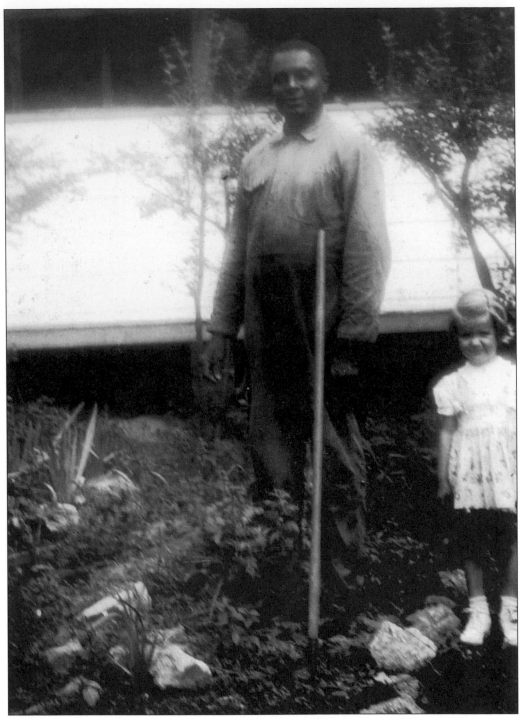

Alfred Horn did yard work for the Cooper Family on East Point Street. Here he stood in the yard with Elaine Bruce. Horn was a veteran of World War II.

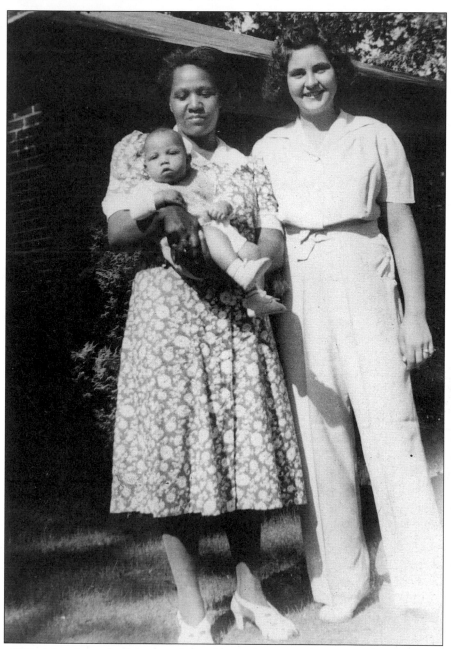

Classie White is pictured above, with Barbara Christian Brown (future East Point City Councilwoman). Classie worked as a domestic for the Christian family for many years. She is shown holding her nephew "Boy Blue." Another resident of East Point's black community, John Lee Benjamin became the first black to become a long-distance truck driver. An employee of Armco Steel Co. in East Point, Benjamin also became a demonstrator of the latest trucking equipment. He retired in 1967 after 37 years with Armco. Another occupation necessary for the sanitation of the community involved the collection of refuse on what the kids called the "honky cart." Joe Jenkins worked in this capacity for the city of East Point remembered Mildred Oliver. (Courtesy of Barbara Brown.)

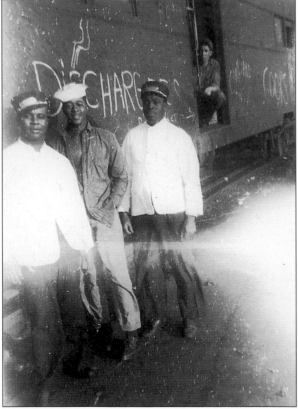

There were several men who worked for the railroad, including Frank Chunn, Claude Woods, and Otis Jackson. Frank Jackson, Ed Riley, and Dewey Ransaw worked as railway employees. O.J Hurd (far left) worked as a pullman porter during the 1940s.

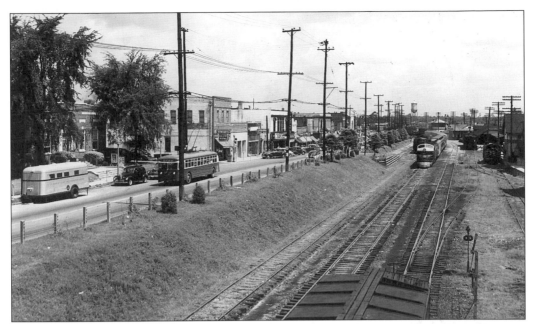

During the 1920s East Point began to fulfill its potential not only as an industrial city, but as a regional commercial hub as well. Availability of good public transportation enabled shops and stores on Main Street to thrive even before the advent of the automobile. Noticeably absent, however, were any black-owned businesses in the city's downtown shopping area. East Point differed in that respect from cities located to the south, such as College Park, Fairburn, and Palmetto, each with small areas of black-owned or operated businesses. (Courtesy of East Point Historical Society.)

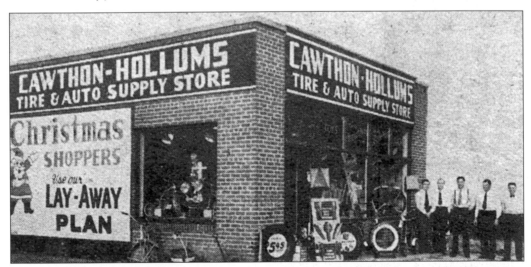

Because of this lack of entrepreneurship, black residents became valued customers of East Point's white establishments along the Main Street shopping corridor. Many took advantage of home delivery of groceries and of the availability of credit purchases. Mildred Henderson Oliver recalled that "everyone had an account with Cawthorn and Hollums Appliance Store." She recalled in 1947, after attempting to help her scrub diapers on a rub board, her husband rushed out and purchased a washing machine at Cawthorn and Hollums.

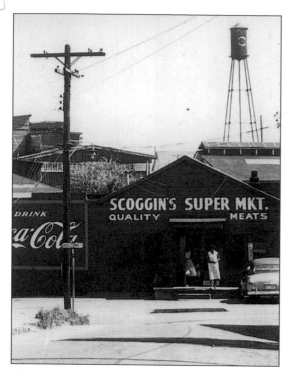

Scoggins grocery store was a staple in the community for more than 50 years. Ralph Scoggins, the owner, later moved to Bayard Plaza and opened the Thriftway grocery store, hiring African Americans as cashiers and stock clerks. For many years there were white-owned grocery stores that existed in the community. On East Washington Avenue—the buffer zone between the black and white communities east of the railroad tracks—Mr. Sutton had a grocery store that was later operated by Sam Ramsey Sr. During this decade the focus for black service-oriented businesses and stores began to shift south of Washington Avenue along Randall Street to its intersection with Holcomb Avenue.

During the early 1930s, African Americans in East Point patronized numerous cafes and clubs where there was a piano or jukebox. Some of the more popular ones included Dyer's Cafe, Will Long Cafe, Will Bixby Cafe, Jess Freeman Cafe, J.B. Bailey Do Drop In, Lisa Scott Cafe, Squeeze In, Bill Sims Cafe, Sidney Ross Cafe, Martin Lumpkin Cafe, and the infamous Zanzibar. Above Lucy Willis stands in her restaraunt, Lucy's Inn, located on Martin Street.

J.B. Bailey, who ran a lumber and coal yard on Barretts Avenue, also operated a cab company. He is perhaps best remembered for the cafeteria and snack bar he operated out of his home on the corner of Leavens Street and Holcomb Avenue. Shown hanging out at Bailey's place are (kneeling from left to right) Eddie High Jr. and Nathaniel Hearn; (standing) Eddie Lee Willis, Otis, and Kid Starr. (Photo courtesy of Harold Hearn.)

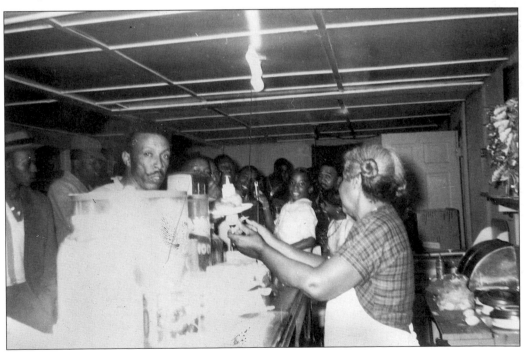

Located above the Lige Sims Funeral Home was a restaurant owned and operated by Myrtice Wynn. A crowd stands at the counter waiting to be served, c. 1959. (Courtesy of Harold Hearn.)

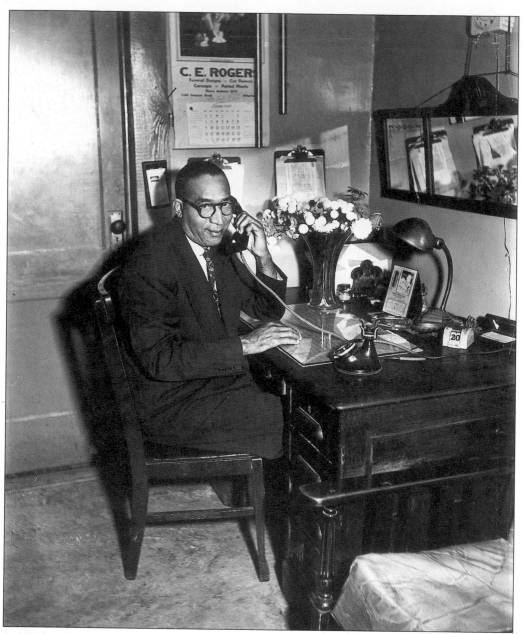

Annie Mae Head, daughter of a well-known minister and East Point socialite, gained a husband and a business partner when she married Henry Walker in 1929. Walker was born in Monticello, Georgia on July 27, 1900. During the early 1900s he attended Morris Brown College and later graduated from Worsham College of Mortuary Science in Chicago, Illinois. By 1938, the husband-and-wife team opened the Walker Funeral Home at their residence in East Point on the corner of Bayard and Calhoun Streets. Walker experienced the horrors of racism when one evening while driving outside of Atlanta. He was stopped by two county sheriffs, ordered out the car, questioned, and then severely beaten. (Courtesy of Charles Barlow.)

Annie Mae Walker was the daughter of Rev. Phinous (Pheneas) Head and Mrs. Mariah Head. She attended Spelman High School where she completed her studies in 1924. Before her death in 1990, the Ninth District of the Georgia Funeral Service Practitioners Association honored her in 1976 as one of the "pillars of black Atlanta business."

In 1937, Henry C. Walker and his wife moved to 712 S. Bayard Street in East Point. They continued at this location for four decades until Mr. Walker's death in 1972. Throughout his years in East Point, Mr. Walker was a business and community leader who acted as a role model for aspiring young black men, including Gus Thornhill, who worked as an apprentice for him.

The community had several funeral homes. Cox Brothers Funeral Home, (Charles S. and Gabriel), whose main operation had been at 258 Auburn Avenue in Atlanta since 1900, had several locations throughout the city including Decatur and East Point. They opened a branch facility at 531 Holcomb Avenue in East Point in 1931. In 1933 Elijah (Lige) Sims, who had

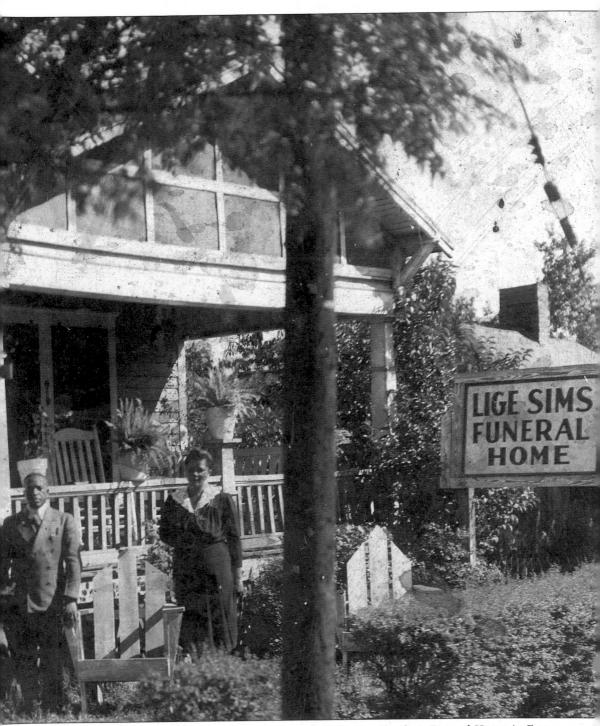

opened a barbershop at 431 Holcomb Street, managed the Cox Brothers Funeral Home in East Point before opening his own funeral home at his residence on Holcomb Street. (Courtesy of Nevada White Price.)

FRIENDLY PEOPLE'S BUS LINE

REASONABLE CHARTER RATES

Telephone PO. 6-2994

O. J. Hurd - Owners - J. E. Johnson

1960		JANUARY				1960
SUN.	MON.	TUES.	WED.	THURS.	FRI.	SAT.
					New Year 1st	2
3	4	5	6	7	8	9

Oscar James Hurd organized the Friendly People's Bus Line in 1952; his daughter Pat came up with the name. The line provided service between the East Point business district and the black community, an important development following in the wake of the Atlanta Transit Company's refusal to extend bus service to the black community. Hurd and others were instrumental in registering African Americans to vote.

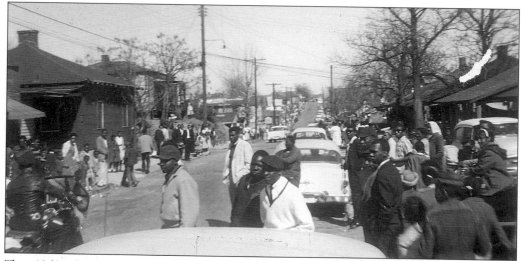

The 1940s brought changes in economy and lifestyle in East Point's African-American community. As more people moved in, there was a greater need for cafes, clubs, and taxicabs. Sidney E. Ross Sr. opened a café on Holcomb where patrons could enjoy sandwiches and snacks in the privacy of booths. For entertainment in the community, the Lovett and Eason families opened the Zanzibar Club, which offered music, food, and entertainment. It was located on Randall Street. J.R. Chambers purchased a Ford automobile and began operating a taxi service called GO-CAB from the basement level entrance of the Zanzibar Club. This photograph depicts a busy Holcomb Street in the 1950s. (Courtesy of Harold Hearn.)

Six
SOCIAL, CIVIC, AND COMMUNITY ORGANIZATIONS

A 1950s photograph shows members of the Hyacinth Club, East Point's oldest club for African-American women. From left to right are (front row) Blanche Gay McElroy, Mariah Head, Vivian Smith, Idella Woods, Gertrude Barlow, and Arno Bush; (middle row) Mary Spears, Annie Mae Walker, Mrs. Hayes, unidentified, Iona Robinson, and Rosa Glass; (back row) Rubye Chunn Heard, Georgia Saunders, Arno Woods, Evangeline Woods Gafford, Stella Freeman, and Cleo Burnett.

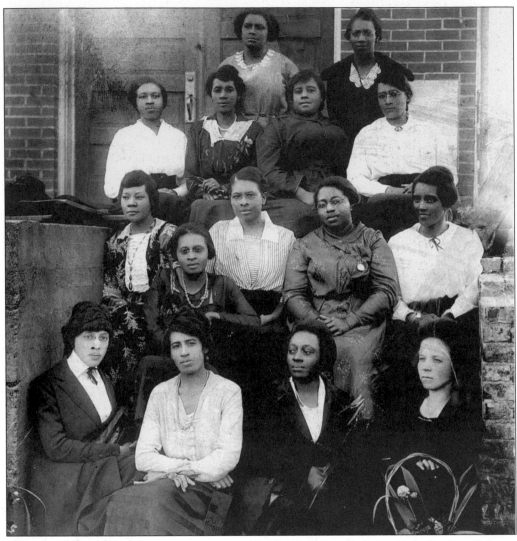

Under the leadership of Mrs. Cora Lee Kempson Glenn, the Hyacinth Art Circle Sewing Club was organized in 1913. The club's purpose was to provide fellowship and to challenge women to produce beautiful, decorative, and useful articles of needlework. Through the years this group became a community service organization, with membership limited to 15. The observance of May Day prompted a showcase of their needlework skills when each member was required to wear a garment she designed and made. Comprised now of daughters and granddaughters of founding members, the Hyacinth Art Circle has continued this concept of fellowship and service through monthly meetings. The membership roster from 1913 through 1938, during the presidency of Mrs. M.A. Head, included Mrs. C.L.K.Glenn, Mrs. Pattie L. Holmes, Mrs. M.E. Lofton, Mrs. Eva Mauldin, Mrs. Pearl Sewell, Mrs. May Gaye, Mrs. M.A. Head, Mrs. Ida England, Mrs. R.B. Murray, Mrs. Julia Dozier, Mrs. Minnie Green, Mrs. Mattie Vinson, Mrs. G.W. Sanders, Mrs. Roxie A. Farmer, Mrs. Rosa Glass, Mrs. J.E. Mitchell, Mrs. Mattie R. Westfield, Mrs. Lillie Sims, Mrs. Emma Conkie, Mrs. Lillie B. Bryant, Mrs. Ophelia Davenport, Mrs. Marie Collins, Mrs. Evelyn H. Shannon, Mrs. Gertrude.V. Barlow, Mrs. Blanche McLeroy, Mrs. Stella Freeman, Mrs. Annie Mae. Walker, Ms. Irene Piltry, Ms. Ruby C. Hurd, Ms. Cleo Burnett, Ms. Ophelia Hayes, Ms. Jenine Mitchell, Ms. Catherine Warren, and Ms. Mary Jones.

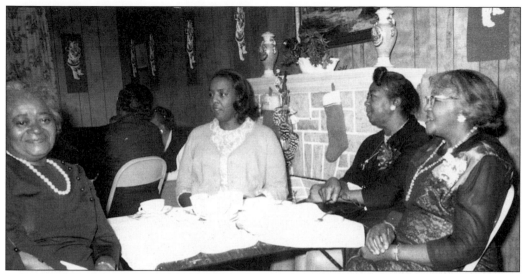

Evangeline Wood (left) and Blanche McElroy (right) are pictured in this 1960s photograph of the Hyacinth Club. Since the club's inception, each hostess serves refreshments following the meeting. Wilson Head recalled that during the 1920s and 1930s, each hostess would attempt to "outdo" the refreshments of the previous one until it reached a point where the ladies could no longer afford to prepare such elaborate meals and a decision was made to return to more simple refreshments. The Head boys were happy when the club met at their home because it meant "goodies" for them. (Courtesy of Pat Hurd.)

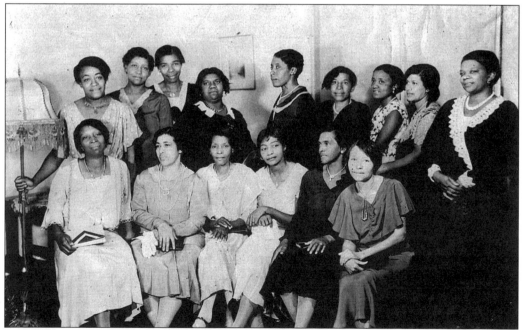

Members of the White Rose Handy Craft Sewing Club are pictured in this 1932 photograph. From left to right are (front row) Hattie Allen, Annie Belle Earl, two unidentified, Geneva Alexander, and Nannie Lee Simmons; (standing) three unidentified, Annie Bell Murphy, Maybelle Shannon, unidentified, Ann Render, Alberta Lyons, and Betty Irvin.

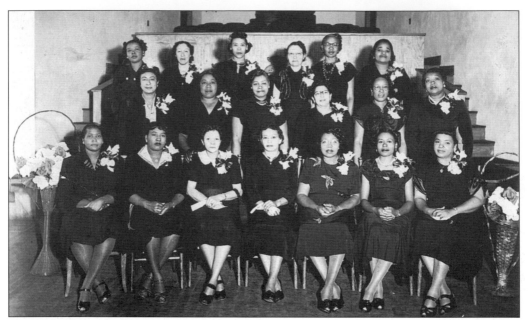

The Rose of Sharon Club was organized in 1941 at Siloam Baptist Church. Pictured in this 1952 photograph, from left to right, are (front row) Willie Fuller, Carrie Starr, Gertrude Barlow, Cleo Burnett, Hattie Bell Middlebrooks, Hazel Lyons, and Annie Walker; (middle row) unidentified, Mariah Williams, Iona Robinson, Alberta Lyons, Bell Turner, and Ethel Trice; (back row) Annie Westbrooks, Mrs. Simmons, Ora Farmer, Nannie Lee Simmons, Gertrude Cloud, and Clara Day.

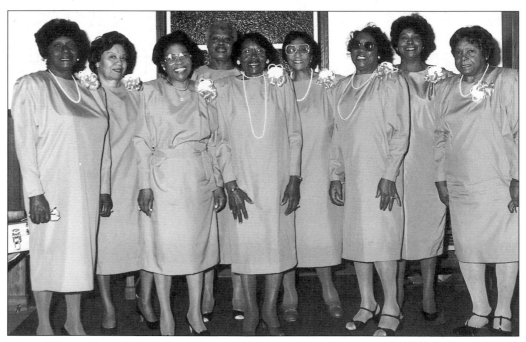

Later club members, from left to right, are Margaret Burnette, Lavonia Mathis, Mildred Day, Wilene Strickland Lattimore, Hazel Lyons, Willie Fuller, Carrie Starr, Eunice Lyons, and Annie Walker.

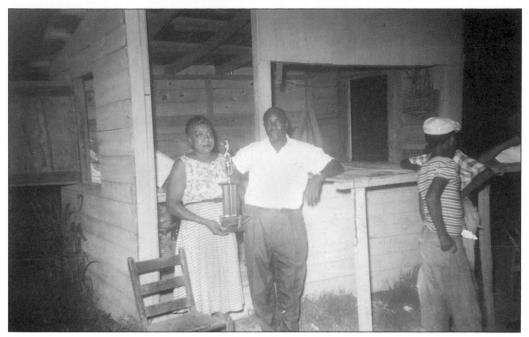
Shown are two South Fulton Booster Club members, Ethel Trice and O.J. Hurd, at a baseball game *c.* 1950.

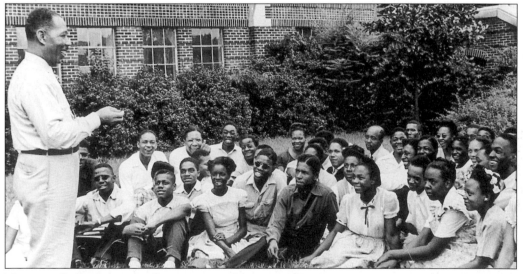
The Friendly Twelve, a social organization for young African-American women in East Point, was organized during the early 1920s. African-American students living in the Atlanta-Fulton area who wanted to attend high school had to enroll in the academy section of one of the black colleges or, after its opening in 1924, Booker T. Washington High School. Most of them made the round-trip each day on the trolley. Organizations such as the Friendly Twelve enabled students to have social contacts in their home communities and provided activities such as picnics, outings, and hiking. Annie Mae (Head) Walker was one of the members of the Friendly Twelve. Shown above were students on the lawn of Washington High School (at a later period) listening to principal C.N. Cornell.

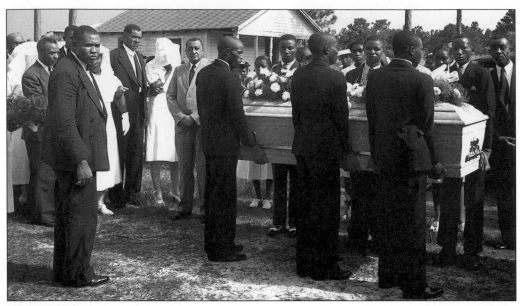

An organization in the black community that grew out of an early cultural tradition was the Progressive Lodge, a burial association where membership dues were collected monthly, invested, and held in trust until a member's death. Funeral rites and a proper burial were important aspects of black culture. In addition to offering the security of burial insurance, they functioned as a social organization as well, sponsoring dinners and dance parties for members and guests. By the 1940s, a funeral cost around $800 (including casket and vault). After the black section of the Connally Cemetery was closed to the public, there was no place for black burial in East Point. The nearest cemetery was in College Park, but there were two others as well—the park-like Lincoln Cemetery in Northeast Atlanta and Southview on Jonesboro Road.

'32

THE AJAX CLUB

'49

One of the most influential organizations in the black community prior to World War II was the Ajax Social Club founded in 1932. Men who were honest, temperate in their habits, and of good moral character could be presented for membership. The club gradually moved from a strictly social group to a more activist role by forming a community civic club. The membership would be limited to 12. The main concern of this group was to secure property for a community park and recreation area. Members contributed $10 each to purchase land on S. Randall Street and, after purchasing it, petitioned the city of East Point for help in securing playgroup equipment.

The Pride of East Point Lodge Number 630, a black Masonic organization, was formed in East Point in 1943. Sidney Ross Jr., a licensed plumber, was the Worshipful Master. The lodge, a part of the Prince Hall Order, was active until 1962. Lodge meetings were held in Neriah Baptist Church. Ross also helped organize a Black American Legion in East Point in 1947. Other co-founders included Emerson Sims and Harold Banks. This very successful organization operated for several years on the second floor of the Lige Sims Funeral Home on Holcomb Avenue. The building was torn down during Urban Renewal development in the early 1960s and the American Legion Post was eventually disbanded.

$1.00　　　Buy As Many As You Wish　　　$1.00

BOND OF CHRISTIAN CHARACTER

Help Us Build A House on the

EAST POINT FREE PLAYGROUND

"What a man does for himself dies with him; but what he does for his community lives long after he is gone."

—Theodore Roosevelt

EAST POINT COMMUNITY CLUB

$1.00　　　　　　$1.00

Pictured above is a bond used to acquire funds to build a house on the East Point Free Playground.

W.A. Quillian was instrumental in organizing the first African-American Boy Scout troop in East Point. Below, he is shown with several of the city's troop leaders at Friendship Baptist Church. Quillian is standing second from the left on the second row; the young boy scout next to him is Maynard Jackson, who would go on to be elected the first African-American mayor of Atlanta. Quillian organized a Fifth Sunday union.

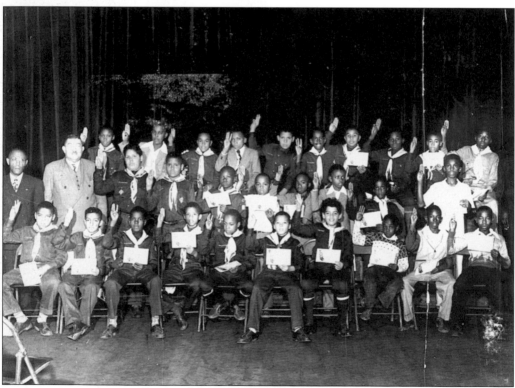

When new ward lines were drawn following the annexation of Egan Park to East Point, the black community was included in the Fourth Ward. With few registered voters, political activity centered around Charles A. Green, an acknowledged community leader, advocate, and spokesman. Quite a stately and handsome man, Green had worked with the Boy Scouts, Father's Civic Club, the NAACP, and the Urban Renewal Committee. He was a member of Siloam Baptist Church and chaired the Deacon's Board. Green had been employed as a maintenance man at the University Homes Apartments and Jefferson Avenue Baptist Church. Green was instrumental in the city of East Point opening a swimming pool for African-American children.

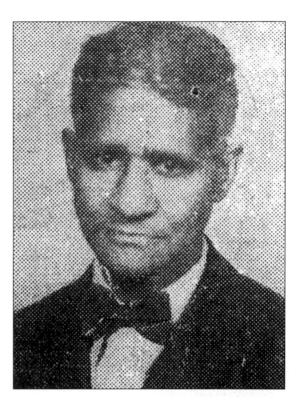

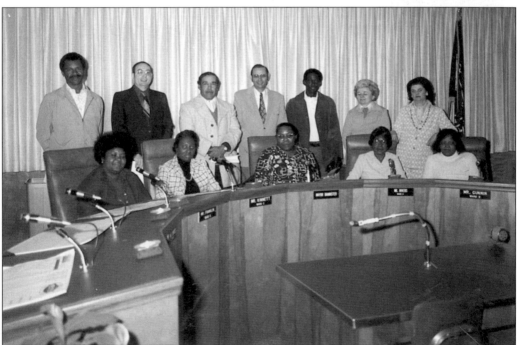

Pictured above are the members of the bi-racial council which met in East Point City Council Chambers. The organization of the group enabled all citizens of East Point to discuss issues affecting the community.

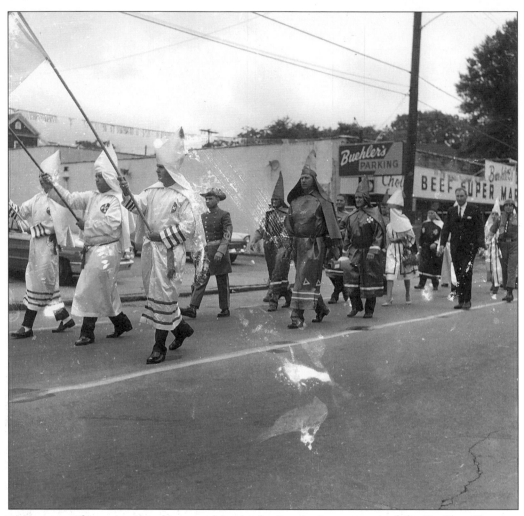

As in many African-American communities in the South, the presence of the Ku Klux Klan was prominent and visible. The Klan rode through the streets of the Fourth Ward "parading" in their hoods and robes, usually in a Model Truck or several cars, sometimes carrying a body, according to James Jackson. Many could see the Klan coming cross Central Avenue across the railroad track. Betty Trice Ross remembers running from the theater after seeing the Klan moving towards her community. Often they would burn a cross in a resident's yard, indicating that that person was soon to be their target. A local man, Frank Hightower, would go and pick up the cross only to be later assaulted by the Klan. Hightower, a member of the East Point Baseball Team, would be severely beaten. The Klan was disbanded following the 1941 beating death of white resident Ike Gaston in East Point, a white barber who was taken to a field near Redwine Road. They did not realize that they had beaten him to death. Fulton County solicitor Dan Dukes sent a team of investigators into the African-American community of East Point to gather up all of those who had been beaten by the Klan. A case was made and convictions were done.

Seven
ENTERTAINMENT AND RECREATION

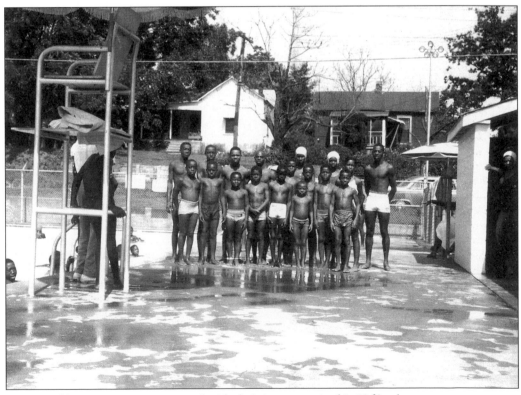

A group of beginner swimmers posed with their instructor in this 1960s photo.

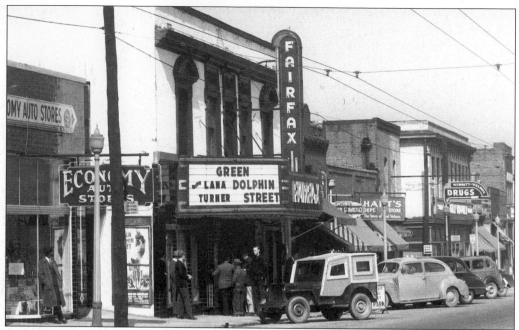

The city of East Point had two segregated theaters including the Fairfax Theater, located on Main Street, and the East Point Theater. The Fairfax reopened in May of 1931. James Jackson recalled that people came from all over the county—as far as Fairburn—to go to a movie at the Fairfax. African Americans were allowed to patronize the theater by using the colored entrance to climb the steps to the balcony. Fisher Kimble worked the colored balcony. (Courtesy of East Point Historical Society.)

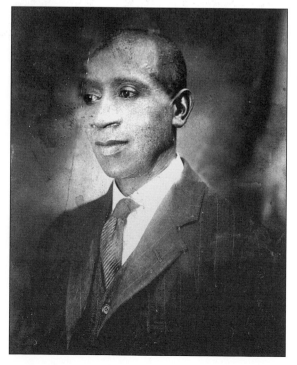

Frank Head for many years worked at the Fairfax as the "unofficial manager" of the colored section collecting tickets in the balcony. Frank left East Point School after ninth grade and went into the army for three years. He was also known to repair radios in his spare time. Head had three brothers—Marvin, Glen, and Wilson. (Courtesy of Charles Barlow.)

Some of the residents of East Point recalled that as kids and teenagers they would attend the annual fair at the Lakewood Fairgrounds. They would walk over to the park and attend the fair, which began as an annual Atlanta tradition in 1916. Shown is an aerial view of the Lakewood Fairgrounds, *c.* 1947. (Courtesy of East Point Historical Society.)

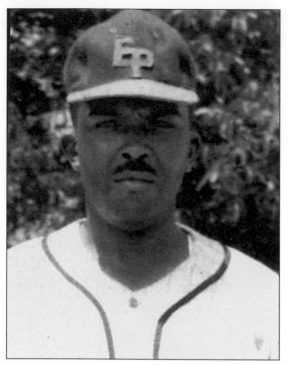

A special sense of pride was felt in the black community in 1948 when the East Point Bears, an amateur baseball team sponsored by Joe Collins and Neal Morgan, won the League Championship by defeating an Atlanta team, the Robinson Dodgers. Organized in 1938, the East Point Bears, by their record and level of competition, had attained a status that was equivalent to semi-pro standing. Under the management of "Mote" Sims (left), the Bears continued to be one of the best teams in the region for many years, eventually becoming state champs. Theodore "Mote" Sims worked for many years at Lockheed Aircraft.

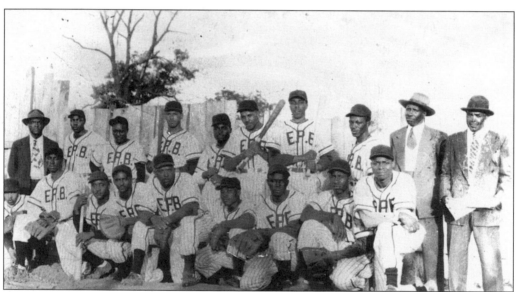

The biggest recreational entertainment during the summer months was attending a baseball game. Every Sunday after church, it seemed as if the entire African-American community would go to the baseball field for baseball games. Vendors sold barbecue, hamburgers, hotdogs, and cold drinks, available at a nearby food stand. The talented players of the East Point White Sox, Swift Black Caps, East Point Bears, and the East Point All Stars entertained fans. Some East Point residents would travel to Ponce Deleon Park to witness the Negro League Atlanta Black Crackers play ball. Alf Ingram, a former Atlanta Black Cracker, would later play for the East Point Bears. (Courtesy of East Point Historical Society.)

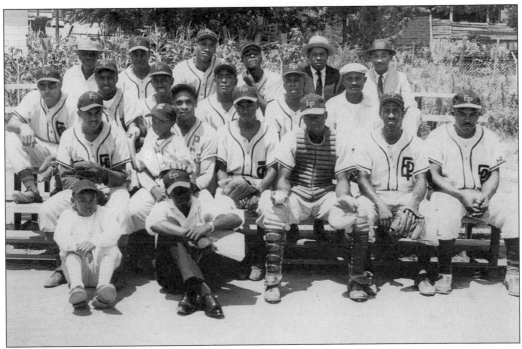

Pictured above are members of the East Point Baseball Team, *c.* 1950, including Wilbert "Chicken Pie" Deion, Clarence Lovett, Alf Ingram, Floyd Talley, Clarence Jackson, Sam Roberts, Charlie Walker, Clifford "Pops" Burnette, Freddie Shepherd, Dave Davis, Neal Morgan, Emerson "Mote" Smith, and Son Howard. (Courtesy of James Jackson.)

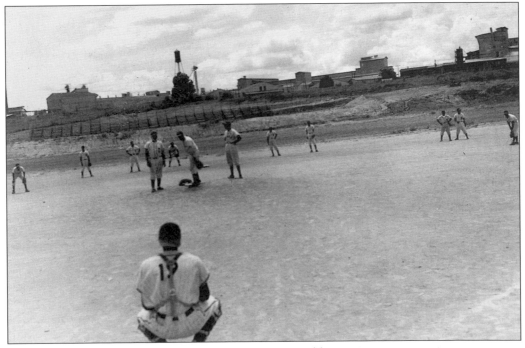

The East Point baseball teams played on the Lige Sims Field.

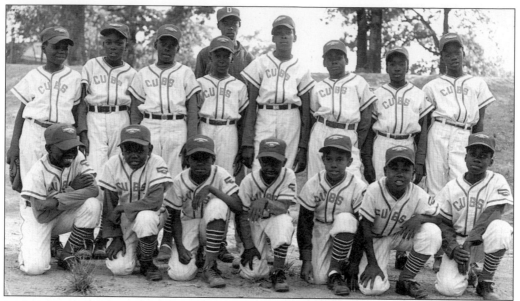

In the spring of 1960, under the leadership of O.J. Hurd, the South Fulton Booster's Club, Inc. organized a sanctioned Metropolitan Pony League for East Point's black community. Named for deceased East Point resident Joe Collins, the Junior League opened its season on May 23, 1963. Mayor Stephens threw out the first pitch at the game. The league was made up of boys between the ages of 8 and 12. Previously denied franchised participation in Little League Baseball, black youngsters in East Point could now participate in the next age level, Pony League (age 12 years), that followed Little League. Later a Colt League was formed for the boys to move into as they grew older. John Milner, who came up through this program, went on to play professional baseball for Montreal in the National League. Pictured above is the East Point Cubs. (Courtesy of James Jackson.)

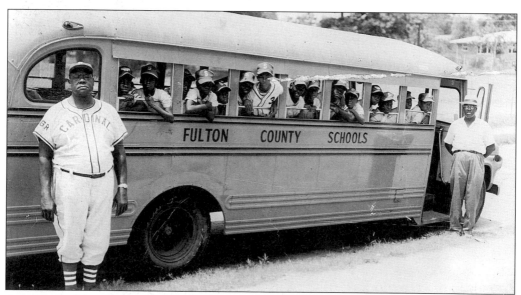

Oscar J. Hurd (standing near bus door) prepares to transport members of the Pony League East Point Cardinals to a ballpark for a game. Standing on the far left is manager Sterling Brannon.

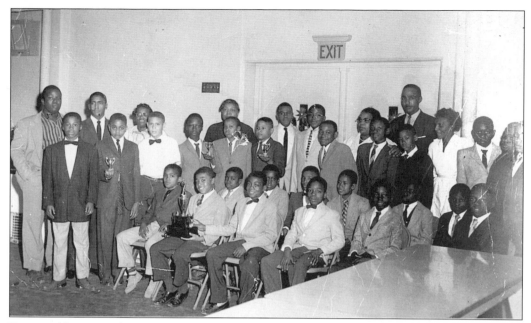

Young athletes are shown with their trophies following the sports awards banquet at the East Point Elementary School. Pictured on the far left is George Clifford "Pops" Burnett, a former member of the East Point Boys Team.

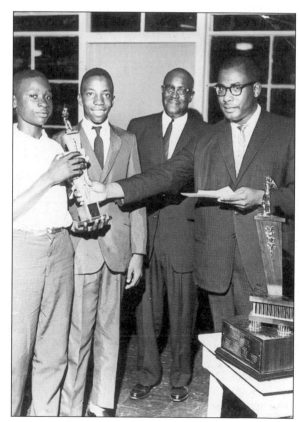

Mr. Johnny Richards, principal of Quillian Elementary School, along with Oscar J. Hurd (second from left) presented athletic trophies to two students in this photograph.

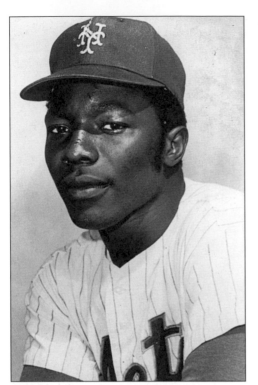

While East Point and South Fulton High School produced many great athletes, only two went on to play professional sports. One of those included John David Milner, who was born in East Point in 1949 to Ms. Addie Milner. He was drafted by the New York Mets in June of 1968 and spent four years with minor league teams. Milner was a left-handed batter and thrower. During his career, he played for the Mets and the Pittsburgh Pirates. He led the Texas League with 100 bases on balls and was second with 98 runs and fourth in homeruns in 1970. While playing with the Mets, he was the leading slugger. Several highlights for Milner included hitting a grand slam for the pirates against the Mets in 1978 and another grand slam against the Cubs a few months later. In 1977, Milner was acquired through a trade with the Mets and reported to the Pittsburgh Pirates. His cousin Eddie Milner played as an outfielder for the Cincinnati Reds. John Milner died in January of 2000. (Courtesy of Betty Trice.)

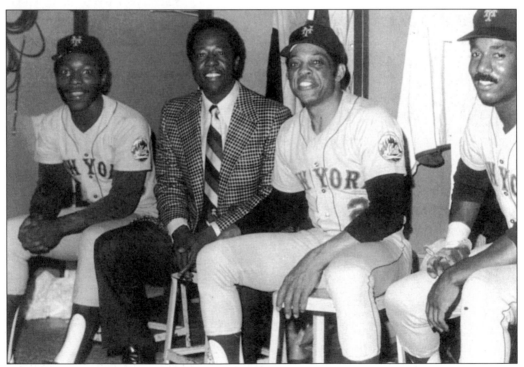

Millner (left) is pictured with baseball legend and home run king Hank Aaron, Willie Mays, and Tommy Agee, c. 1977. (Courtesy of James Jackson.)

Charlie Greer (right), a graduate of South Fulton High School, went on to play professional football for the Atlanta Falcons. Donald Evans, another local athlete, went on to play professional basketball.

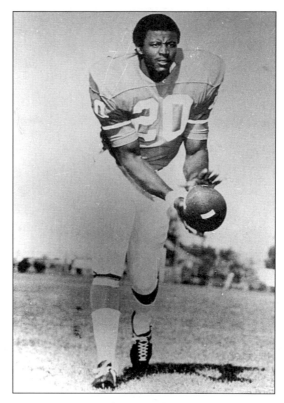

In 1958, Willie Hines became head of the Charles A. Green Center. In 1965, the center reopened with a gym, a swimming pool, and a football field that was named in memory of Clifford Burnett. Hines was a native of South Carolina. He volunteered for the army and was sent to Korea in 1950. During his service, he lost his right arm when the truck he was riding ran over a land mine. He was discharged in 1954 and entered Morehouse College where he graduated in 1958 with a degree in business. Some of the athletes that he coached included ABA basketball star Don Adams, major league baseball player John Milner, and former Atlanta Falcon Charlie Greer. They all attended the Charlie Green Recreation center.

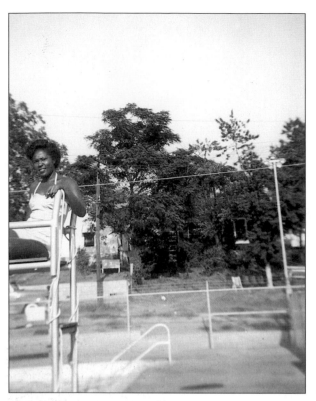

Betty Lovett Dabney was a student at Spelman who worked as a concession operator and taught beginning swimming lessons at the Randall Street pool. (Courtesy of Betty Dabney.)

The opening of the swimming pool for African-American children in East Point was perhaps the most celebrated event in the community up to that time. Members of the Community Civic Club were instrumental in the construction of the $50,000 swimming pool, including Charles Greene, treasurer of the group; Mortician Henry C. Walker; Eddie McMichael, president of the Community Civic Club; and W.A. Quillian, chairman of the committee. Greene reportedly gave the first dollar for the fund-raising efforts. (Courtesy of East Point Historical Society.)

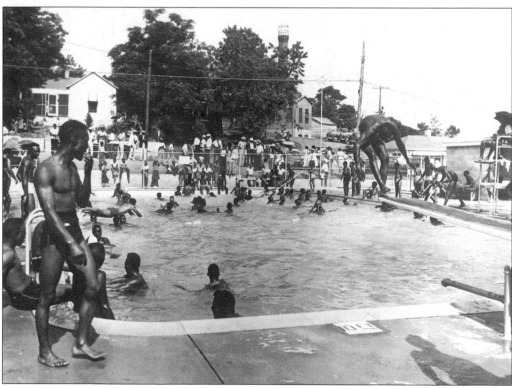

Eight
"GIVE ME THAT OLD TIME RELIGION"

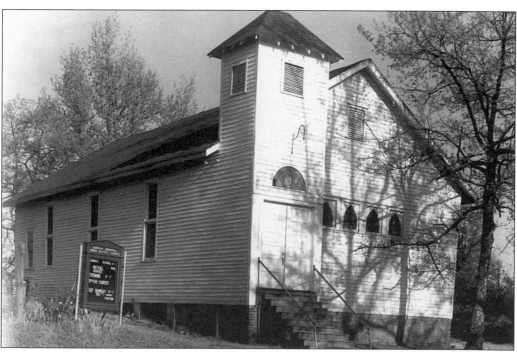

During the summer of 1866, black residents formed the nucleus that became East Point's oldest black congregation, the Union Baptist Church. In 1884 the congregation acquired property on East Cleveland Avenue for which they paid Miss E.A. Mangum $100. Union Baptist Church continued at the Cleveland Avenue site for the next half-century. In 1958, the Tri-City Hospital Authority began to acquire property on East Cleveland Avenue as a site for the proposed South Fulton Hospital. The building that Union Baptist sold to the Hospital Authority was a beautiful white-plank rural Gothic church with a bell-tower entry and a bank of decorative arched windows across the front.

The young minister who came to serve Union Baptist later acquired national recognition, love, and respect as the pastor of Ebenezer Baptist Church and as the father of Dr. Martin Luther King Jr. "Daddy King," as he was affectionately known in later years, accepted a call to this church in 1918. Before and after the ministry of Reverend King, Union Baptist was pastored by a number of dedicated men. Rev. C.L. Daugherty guided the group through the move to East Washington Street. In 1964 the congregation of historic Union Baptist Church called the Rev. B.B. Carter as pastor. Under his leadership the debt on the church was paid off and improvements made to the building. Although there are 150 members on roll, only about 50 are currently active. The years and the move have taken their toll.

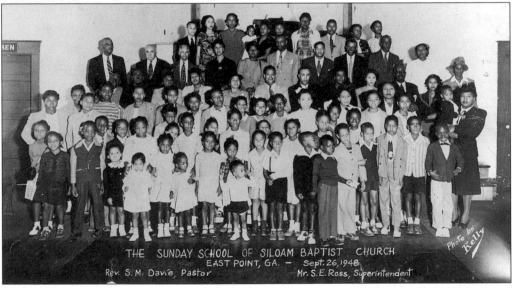

THE SUNDAY SCHOOL OF SILOAM BAPTIST CHURCH
EAST POINT, GA. — Sept. 26, 1948
Rev. S.M. Davie, Pastor Mr. S.E. Ross, Superintendent
Photo by Kelly

In order to be closer to their homes, some members broke away from Union Baptist Church in 1919 to form Siloam Baptist Church. Within a month of organizing, the group secured property at the south end of Bayard Street, a location referred to by older residents as "under the hill," because of the precipitous drop-off in the terrain. Siloam Baptist Church moved up the hill to the top of Bayard Street where, under the leadership of Rev. J.R. Jackson, the congregation constructed a brick sanctuary with a gabled bell tower and full basement. The elevation of the land gave the building a commanding visibility and its location, across from Grant Chapel AME Church gave added significance to the developing neighborhood. (Courtesy of Charles Barlow.)

Siloam Baptist Church stood as a beacon in the African-American community in East Point for over 70 years. This structure was demolished in 1970.

In May of 1971, Siloam Baptist Church moved into their new brick sanctuary. Its classical design featured a pediment porch and columns topped by a steeple. The orientation of the new structure was toward Holcomb Avenue, instead of Bayard Street. The bell from the tower of the old church was mounted in front of the sanctuary, a reminder of the old sanctuary, which had stood since 1919. With 500 members, Siloam was the community's largest black congregation.

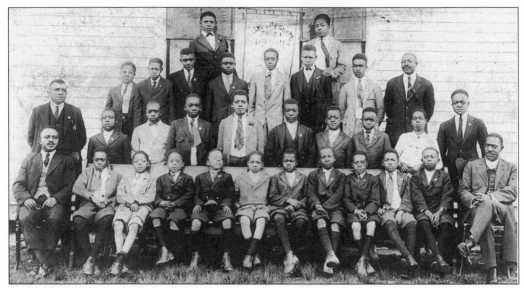

In 1894, Grant Chapel AME Church, East Point's first black Methodist congregation, was organized. The church was named in honor of Abram Grant, the presiding bishop of the sixth district from 1892 to 1896. The group eventually moved to the flats at the bottom of Bayard Street where, in 1912, they constructed a church that also served as a school. In 1912, Grant Chapel AME Church moved to the top of Bayard Street where they became a great force in the community.

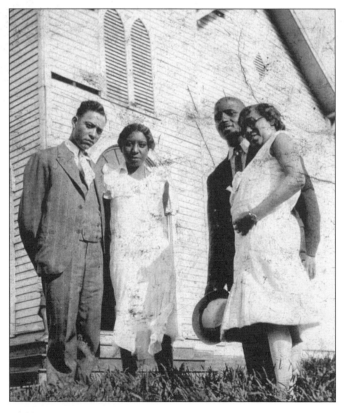

Grant Chapel, an African Methodist Episcopal Church, in a sense represented a "step up" on the cultural ladder. Worship in the Methodist Church, based on liturgy, is more formal and structured. Methodist ministers, in order to be accepted into a conference, must be college-educated and seminary-trained. In contrast, Baptist ministers have less stringent educational requirements and can be licensed and ordained by a local church. AME ministers and the churches they serve belong to a district, a conference, and a jurisdiction, giving them a national affiliation. A presiding elder and a bishop make assignments to local churches, an organizational scheme worked out in the 18th century by followers of John Wesley.

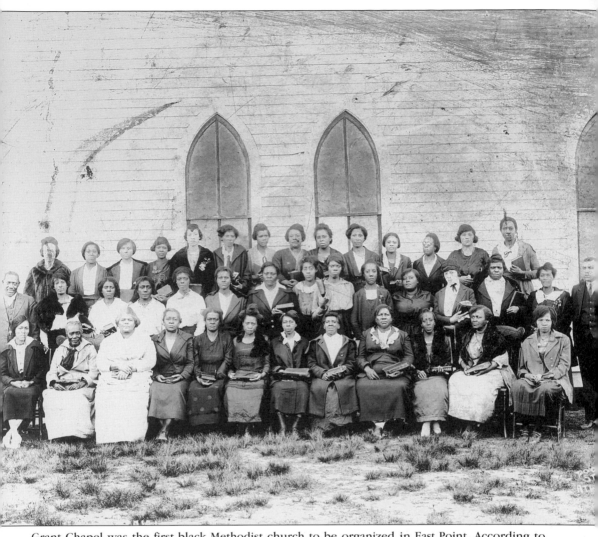

Grant Chapel was the first black Methodist church to be organized in East Point. According to family recollections passed on to Samuel Roberts Jr., the church had its beginnings in 1894 in out door meetings held under a large oak tree that stood near the Southern Saw Works. The Saw Works Company was on Main Street, north of town at a site presently occupied by a hamburger franchise. No written account of the church's early history exists, but if traditional procedure were followed the presiding bishop would have sent a representative to meet with the group. Apparently the group that formed Grant Chapel continued to meet in a location north of town for several years, but eventually moved to the flats at the bottom of Bayard Street where, in 1912, the church constructed a building whose cornerstone lists the pastor as Rev. C.A. Moore. While at this location the church also served as a school for students in the area. Upon moving to the top of Bayard Street, the members built a white plant, board-and-batten church with Gothic-design doors and windows. Grant Chapel soon became a great force in the community.

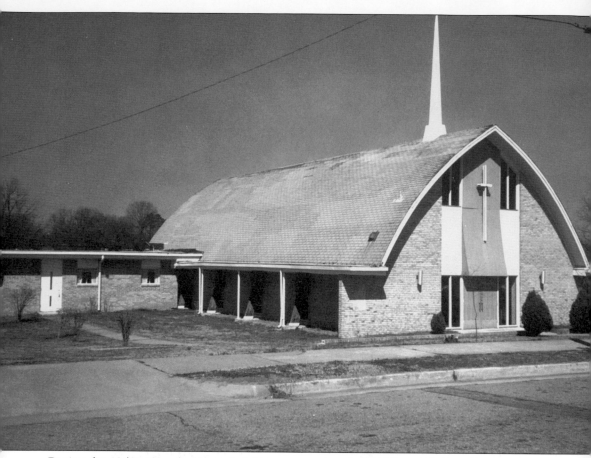

During the 1940s, Reverend Yopp led the congregation. In 1961 Rev. H.E. Terrell was appointed pastor of Grant Chapel AME Church in East Point, providing continuity of leadership through nearly three decades of change in the community. The church has had numerous pastors who served faithfully. The remodeled Grant Chapel AME Church appears in the photo above. Most recently, Rev. Brian Hart is serving as pastor.

A second African-American Methodist Episcopal congregation was established in East Point in 1901. Its location was east of the railroad tracks where Jefferson Park, the city's first trolley suburb, was later developed. Four men, L.D. Carmichael, Henry Bussy, Willie Alexander, and T.J. Alexander are listed in a history of the church compiled by Victoria Berry Arnold. Named for Bishop Willard Francis Mallalieu, the congregation was affiliated with the "Northern" branch of Methodism.

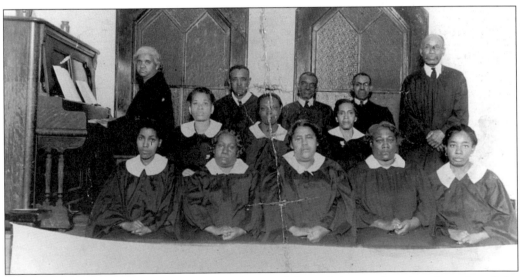

In 1924, Mallalieu Chapel Methodist Church moved from their storefront location, site of the construction of William A. Russell High School, to a "shotgun" house on Randall Street, just north of Georgia Avenue. In 1925 the congregation bought two lots across Randall Street and began construction of white clapboard, rural Gothic church. Reverend Daniels was the pastor at the time of the move. The church had pointed arch windows across the front and sides. During the 1940s, a young preacher named L. Scott Allen served as the pastor of Mallalieu. He would return again in the 1980s as a bishop of the United Methodist Church. The church experienced great physical, spiritual, and financial growth under Bishop Allen's leadership.

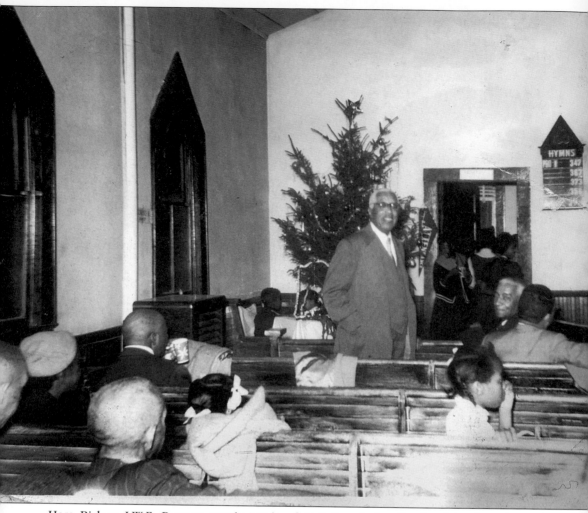

Here Bishop J.W.E. Bowens stands inside of Mallalieu during Sunday School in the 1940s. (Courtesy of James Jackson.)

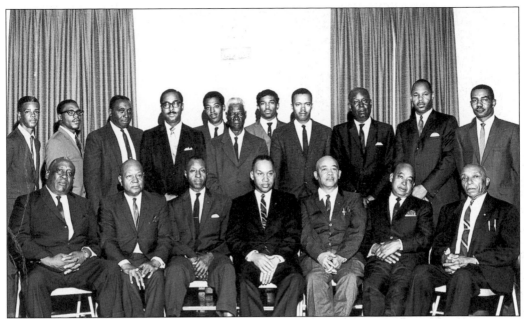

The Methodist Men was a group organized by Eddie McMichael Sr. Seated from left to right are T.Y. Fletcher, Herbert Arnold, Eddie McMichael Sr., Rev. H.C. Fisher, Floyd Crawford, Oscar Bidgood, and Charlie Walter. Standing are Joseph Crawford, Wimberly Hale, Bennie Shafer, Earl Dabney, James Dyer, Jack Bailey, Ronsonn Jackson, ? Davis, Malcom Arnold, Eddie Mcmichael Jr., and Howard Haygood. Many of the old members were joyful on January 5, 1969, when the church entered the new sanctuary (below) at 2941 Randall Street. The celebration was known as Entrance Day for Mallalieu United Methodist Church. During Urban Renewal the congregation replaced the white clapboard Gothic church with a modern brick design, seen below. An additional lot was acquired for parking. Rev. H.C. Fisher was pastor during these years of change.

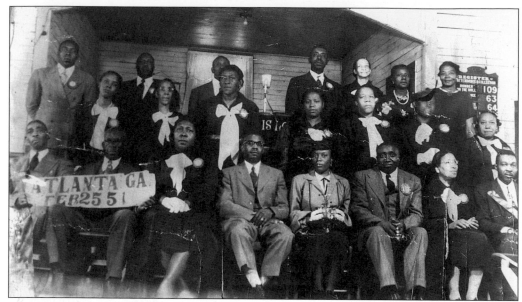

Neriah Baptist, the youngest of East Point's historic black churches, was formed in the early 1920s by people living near the Georgia Railway and Power Company right-of-way between East Point and Hapeville, bordering sections known as Junglefoot and New Town, the route of the streetcar tracks through the Cotton Mill District. The congregation was served by a succession of three ministers before calling the Rev. Robert Nathaniel Martin in 1934. Pictured above in this *c.* 1952 photo, from left to right, are Rev. A.B. Lemon, Reverend Wright, Onita Eason, Rev. R.N. Martin, Mrs. Ann Martin, Deacon Herman Benton, Nellie Cousin, and Willie Seals.

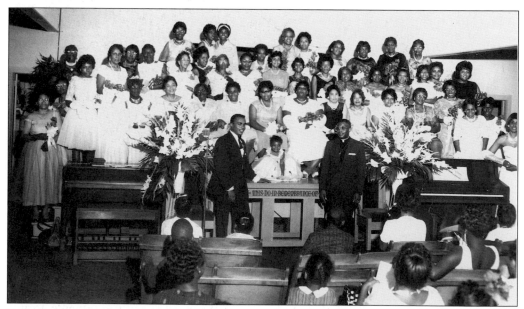

Reverend Martin grew up in Campbell County. At age 10 he began baptizing and performing burial rituals for chickens in his family's farm. For 56 years Reverend Martin served as pastor of Neriah and he served for 37 years as moderator of the Cane Creek District Association of African-American Baptist churches.

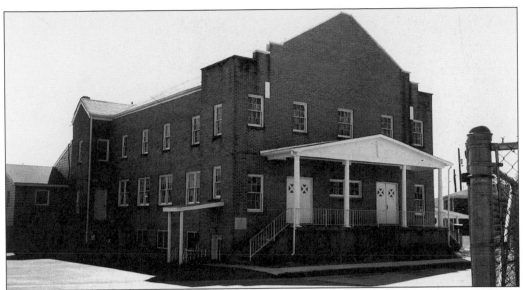

In 1937, Neriah's congregation relocated to East Point, completing a frame structure on Barrett Avenue. The church replaced its white frame building with a new gray brick structure patterned after a church on Stewart Avenue in Atlanta. Reverend and Mrs. Martin dedicated the church on Sunday April 27, 1952. The new church faced on Barrett Avenue, but after Urban Renewal, Barrett was closed and Holcomb Court was built, giving Neriah a new street address.

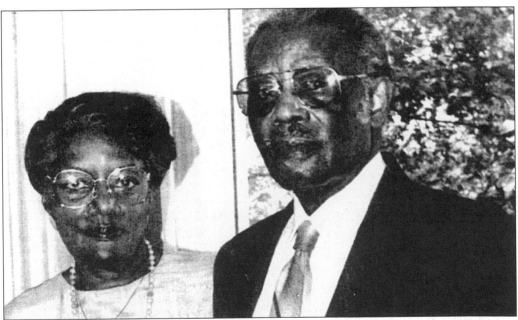

Rev. and Mrs. R.N. Martin are shown in later years in the photo above. In 1949, under the leadership of Walter A. Quillian, East Point's six black churches formed a Sunday School Union. Quillian, a member of Mallalieu Methodist Church, saw the union as a way to promote greater cooperation and understanding among the churches, none of whom had worship services scheduled on fifth Sundays. This joint Sunday school meeting rotated among the churches— Mallalieu, Grant Chapel, Siloam, Evans Grove Baptist, Union Baptist, and Neriah Baptist.

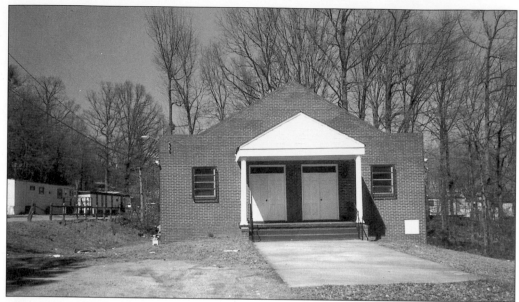

When Union Baptist Church left the Grabball area it relocated to Washington Street.

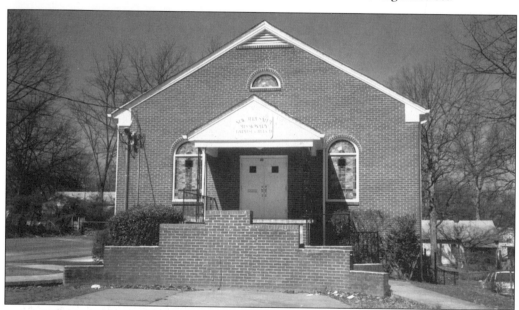

Evans Grove Baptist Church was organized in 1907 on Nabell Avenue. The church was the focal point of a small black residential community whose roots reached back to post-Civil War settlement. The land had been part of the original Connally plantation. The congregation of Evans Grove Baptist Church left its original location in the Grove Avenue area and moved east across the railroad tracks to Francis Way in the city's industrial section. Here they built a simple frame structure in a section of worker housing. The church purchased the site and sanctuary of the First Congregational Holiness Church on Hendrix Avenue. The latter congregation was constructing a larger facility on Sylvan Road, near the Owens-Illinois glass plant. With this move the church became the Greater Evans Grove Baptist Church, and in 1980, the name was changed again to the New Jerusalem Missionary Baptist Church.

Nine
CIVIC AND POLITICAL GAINS

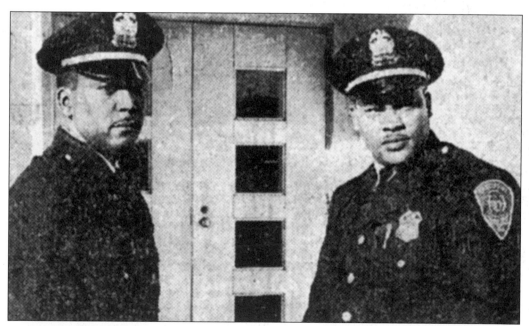

The relationship between the East Point Police Department and the Fourth Ward has been one filled with interesting stories and anecdotes. Since the turn of the century, several men have served as police chief, including J.W. Miller and W.H. Tyler. Tyler, who joined the department in 1923 as an officer, developed cordial friendships with some of the community's African-American leaders. It was Tyler who went into the Fourth Ward and approached mortician Henry Walker to help him find his first African-American policemen. In the summer of 1964, a group of civic and church leaders appealed to the Atlanta Summitt Conference; Rev. Samuel Williams, pastor of Friendship Baptist Church and president of the Atlanta Branch of the NAACP; and George Beck of the Urban League for help in their efforts for the African-American citizens of East Point.

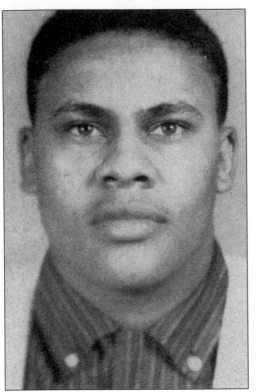

As a child, Gus Thornhill delivered newspapers in the community. He was born in the heart of East Point to Rev. Gus Thornhill and Mrs. Irene Thornhill. Gus Thornhill, a 1958 graduate of South Fulton High School and one of the first black men hired as a police officer in East Point, opened a funeral home at 1315 Hendrix Avenue. George Burnett and Gus Thornhill were suggested as officers by local mortician Henry Walker. After their training, Burnett and Thornhill worked only on the night shift and only in the Bayard/Washington Circle community, which was the predominately African-American neighborhood. The white officers referred to it as the "black shift." They were not allowed to arrest white persons on their own but had to call in a white officer to make the arrest. The third African-American officer to join the force was Leonard Tinch. Gus Thornhill continued his career with the East Point Police, serving in each of the departments, and moving up through the ranks to become lieutenant, captain, and major before his retirement.

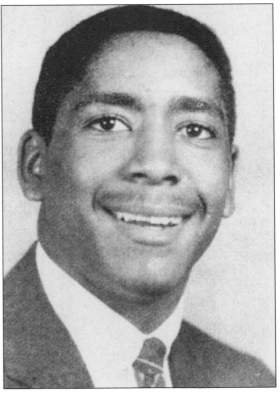

Officer George Clifford Burnett was killed in the line of duty on July 17, 1966, less than a year after he was hired. On a routine patrol he signaled to the driver of a car traveling north on Central Avenue to pull over to the curb. The driver panicked and opened fire on Officer Burnett at point-blank range, killing him instantly. A memorial fund was established to place a marker at the entrance to the athletic field at the Randall Street Recreation Center. George Burnett Jr., an outstanding athlete at South Fulton High School, had played minor league baseball prior to returning to East Point.

Following the retirement of Police Chief John McClendon in 1995, Hank Harbin was appointed as interim chief. City Manager Joe Johnson announced the vacancy and opening of this position. Over 94 applicants applied. One of those persons included police veteran Frank Brown. Officer Frank Brown joined the East Point Police Department in 1967 and was a 29-year veteran when he was chosen out of 94 applicants for the position of police chief, becoming the first African American to hold the position. A native of Fayetteville, Georgia, Brown moved to East Point in 1971. He graduated from Clayton Junior College and Georgia State and spent two years in the Air Force. Brown also received a masters in management and supervision from Central Michigan University and graduated from the FBI Academy in 1990.

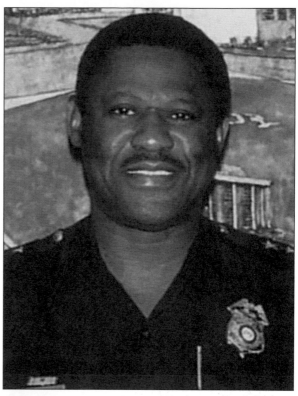

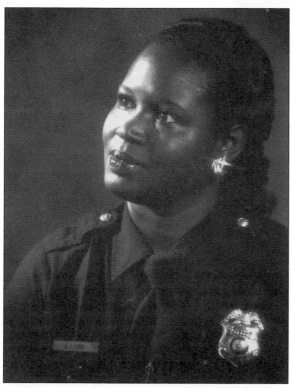

Carolyn Ford Davis became the first African-American female officer for the city of East Point on March 23, 1981. Officer Davis began her police work at the Georgia State University Department of Public Safety in 1977. She was trained at the North Central Academy in Cobb County. After four-and-a-half years as a patrol officer, on July 1, 1985, Officer Davis earned the title of Field Training Officer. She performed an exemplary task of training newly hired officers. After devoting more than a year of her career to the East Point Drug Squad, Officer Davis was reinstated as a Field Training Officer in the Uniform Division in October 1987. On August 14, 1989, Officer Davis became the first Police Officer assigned to the 911 Center. With very little training from the department, her initiative and drive enabled her to learn and perform the proper techniques in 911 Center Radio Dispatching.

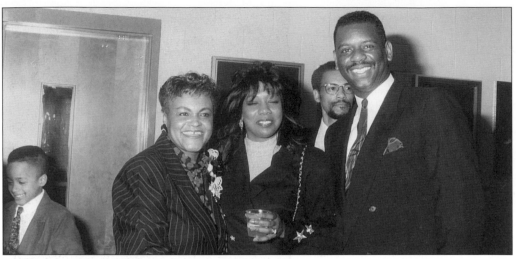

A few years after Ronnie Few graduated from Russell High School and attended Morris Brown College, he integrated the East Point Fire Department and became the first African-American fireman in the city. By 1978 he was promoted to sergeant and lieutenant in 1983. Two years later he became a captain and in 1993, he was named fire chief. Few moved to Augusta, Georgia in March of 1997 after his appointment as that city's first African-American fire chief. In 2000, Chief Few was selected to serve as Chief of the District of Columbia Fire and Emergency Services Department, a post he is currently serving. Chief Few is pictured with Mayor Hilliard (left) and Mrs. Few (center).

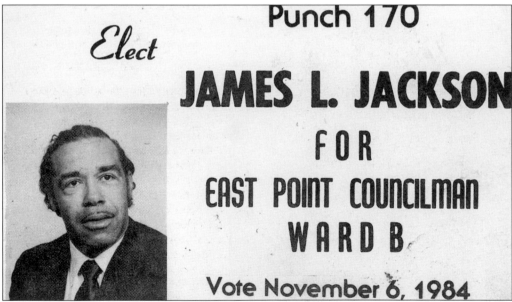

East Point became embroiled in its greatest racial controversy over the reapportionment of the city's four wards. African-American leaders noted that the eight council members, mayor, and city manager were all white. They insisted that the "status quo" in East Point government must change. James Jackson, a well-known community advocate entered the councilman race in 1972 running against Olin Gunnin. Jackson ran from 1972 to 1988 and did not get elected though he had outstanding support from the African-American community.

In September of 1982, East Point City Manager Don Stone resigned from his position and Joe Johnson, who worked as city treasurer, was appointed as the acting city manager. In October, Johnson was confirmed as the city manager, becoming the first African-American city manager of Eats Point. During Johnson's tenure, he managed to propose budgets without tax increases. Johnson recommended that East Point Library be turned over to the jurisdiction of the Atlanta Fulton County Library System since residents were already paying Fulton County taxes. As manager, he orchestrated the widening of Cleveland Avenue as well as the purchase of key properties on the street and the renovation of several recreation buildings, including the Jefferson Street gym. Several referendums were passed to achieve these goals.

That same year, Joe Heckstall became the first African American elected to the East Point City Council. His tenure as a councilman representing Ward D was exhilarating. One of his most memorable fights is when Heckstall complained that the city bidding procedures were not being followed as related to renovation work being done on a historic house, which ultimately would house the East Point Historical Society. In 1987, Heckstall was reelected for a second term on the city council along with Olen Gunnin, Cecil Kennedy, and Clyde Kinnett. Then Fulton County Commissioner A. Reginald Eaves administered the oath to Councilman Heckstall. Heckstall has always been a vocal advocate for African-American representation in East Point. He served three terms as a councilman.

Ann Douglass was elected in the fall of 1988, giving her the distinction of becoming the first African-American female and the first woman in 23 years to be elected to the city council. Her milestones included numerous children's programs, the Weed and Seed Program, and a drug intervention program, which resulted in a large grant to renovate houses, upgrade streets, and rid the community of drugs. Other African Americans who have and are serving on the city council include Threet Brown, Pat Langford, and Melvin Pittman.

With East Point residing in the Fulton County jurisdiction and under the governing authority of the Fulton County Board of Commissioners, several African-American men have represented the needs and concerns of the community to the county. During his tenure, Michael Hightower accomplished many things in office, including the establishment of the Henry James Charles Bowden Senior Citizens Center. In 2000, William "Bill" Edwards was elected to replace Commissioner Michael Hightower.

During the election of 1992, East Point moved into a political arena unmatched by many larger cities including Atlanta. It elected its first African-American female mayor, Patsy Jo Hilliard. Mayor Hilliard was sworn in on January 5, 1993 along with other new and reelected members of the city council including Melvin Pittman, Betty Lane, C. Ann Douglas, who was sworn in by Judge Clarence Cooper. Shortly after her installation, she faced a myriad of old problems including a budget crisis, a low bond rating and low morale among some council members. Her work as a member of the Trust Committee of the Fulton/DeKalb Hospital Authority and the Atlanta Metropolitan College Foundation have been crucial to her sensitivity to the needs of better health care and educational facilities for her constituents.

A NOTE FROM THE MAYOR

I am extremely thrilled by the completion of the most recent work by renowned author and historian, Rev. Herman Skip Mason Jr., documenting the history of the African-American people in the city of East Point, Georgia. His detailed and thoughtful exploration of this important history skillfully captures the essence of the African-American experience in our great city.

Skip Mason's willingness to catalogue the lives of African-American men and women in our community not only allows us to reflect fondly on the past, it provides us an identity as we move forward toward our future. As we start to see our new milennium, this important historical reference is the foundation upon which our future will be cast.

Skip Mason's work is the result of the vision and hard work of several individuals. Our city will forever be grateful to them for their contributions to the East Point Historical Society in its efforts to assist in this project. A special thank you should be extended to Olin and Ora Jean Gunnin for their support. Also, this effort could not have been realized without the direction of Dr. Patricianne Hurd.

The combined efforts of these and other individuals allowed the great Skip Mason to breathe life into the history of an entire group of people. We are forever in your debt.

Mayor Patsy Jo Hilliard
City of East Point

ACKNOWLEDGMENTS

There are many people to thank. I am grateful to committee chair Dr. Patricianne Hurd for her efforts in locating items and making contacts with current and former residents of East Point. Each meeting Pat came in with a bundle of rich material. I appreciate the draft of the article on the development and contributions of Education for African-Americans in East Point that Sam Roberts, and James and Miriam Stokes provided. A special thank you to other committee members including Lucy Willis, James Jackson, Betty Ross, Jacquelyn McMichael, Rosa Sowers, and Jo Jean Taylor for sharing your wonderful images and resources.

The East Point Historical Society has been a great asset to my research. The files and photographs have been made available to me as well as other rich resources. To Olen and Ora Jean Gunnin, I am grateful to you for opening up the collection of the East Point Historical Society. Special thanks to the following persons for sharing their rich stories and for providing photographs for this project: Charles Barlow, Ben Burks, Ora Bolds, Willie B. Caldwell, Bill Cooper, Chief Frank Brown, State Senator Joseph Heckstall, Betty Collins, Carolyn Ford Davis, Councilwoman C. Ann Douglas, Evangeline Woods Gafford, Betty Stokes Green, Harold Hearn, Lydia Murphy Lovelace, Elizabeth Hindsman Higgins, Raymond King, Eddie McMichael, Mildred Henderson Oliver, Former East Point City Councilwoman Barbara Brown, Dr. Betty Dabney, Jo Jean Taylor, Patricia Hurd, James Jackson, Betty Trice Ross, Hattie Strickland, Nevador White-Price, and Andrea Harris Wynn.

Finally, I thank Dorothy Bordenave and Jermaine Ausmore for their valuable assistance and my wife, Harmel, and daughter, Jewel, for their support and encouragement.

BIBLIOGRAPHY

"East Point/South Fulton High School First All School Reunion Booklet: Tell Me Why . . . A Legacy Remembered, May 1996." Unpublished.

Head, Wilson. *Life on the Edge: Experiences in Black and White in North America*. Canada: University of Toronto Press, 1995.

Larcrom, Anne S. for Dr. John M. Matthews. *We Have Come This Far By Faith: A View of Six Historic Churches in East Point, Georgia*. Georgia State University, March 17, 1988. Unpublished.

Morris Brown University Bulletin Catalogue. Edition 1923–1924, 1925–1926.

INTERVIEWS

Transcript interview with Alice Holmes Washington, March 7, 1988.

Charles Barlow, Betty Dabney, Ann Douglass, Patricia Hurd, James Jackson, Eddie McMichael, Jo Jean Taylor, Sam Roberts, Nevador Annette White-Price, Lucy Willis.

OTHER PUBLICATIONS

Atlanta Daily World
Atlanta Journal Constitution/Intown Extra
Atlanta Suburban Reporter, January 24, 1973
South Fulton Neighbor
Southside Sun